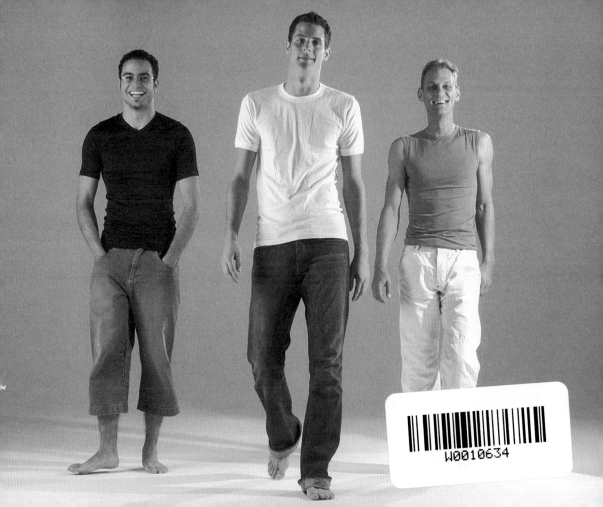

W0010634

UNDERWEAR

© 2003 Feierabend Verlag oHG
Mommsenstrasse 43, 10629 Berlin, Germany

Project managment: Bettina Freeman, Nicole Weilacher
Layout: Michael Baron von Capitaine
Procurement of image material: Birgit Engel, Petra Ahke
Translation to English: Rebecca Holmes-Löffler
Setting: Tobias Kuhn, PARK designstudio, Cologne
Lithography: Kölnermedienfabrik, Cologne
Printing and binding: Druckhaus Locher, Cologne

Concept: Peter Feierabend
Cover photo: © Ruprecht Stempell

Printed in Germany

ISBN: 3-89985-066-1

61-04038-1

UNDERWEAR

Texts: Birgit Engel

Feierabend

CONTENTS

IF YOU'VE GOT IT, FLAUNT IT

Boring, sloppy, unsightly underwear with a worn-out fly – when the dilemma becomes visible under sexy jeans or elegant suit pants, eroticism and desire vanish completely – at least for the viewer. It may well be, however, that the person in question hasn't even realized the problem exists yet.

Yes, that's right! We are talking about men, or more precisely about their underwear. Little heeded and often worn for hygienic reasons only, underwear has long had a lowly standing. Yet it is underwear which shows off a man's most prized possession to its best advantage. After all, experience has shown that the packaging is every bit as important as what's inside!

In the 21st Century, packaging isn't a problem any longer. It has taken a long time for the most intimate item of men's clothing to make the transition from a simple necessity to an attractive fashion element and a topic now taken seriously. Today, the world of men's underwear is more varied and better tailored to meet the needs of its wearers than ever before. No longer must men content themselves with graying underpants. Thanks to

underwear manufacturers and designers, today's undergarments for men put an end to frustration and awaken a desire for experimenting with new fashions. Whether made of fine cotton, micro-fiber or mesh fabric; from classic briefs all the way to the libido-packed jock strap, simple white or animal print – there is something bound to suit everyone's tastes in the endless range of creative styles.

This book shows real alternatives to boring underwear and is naturally also a tribute to man's most prized possession.

And will a man be a little more willing to let down his pants when he finds himself so per-fectly packaged?

But of course!

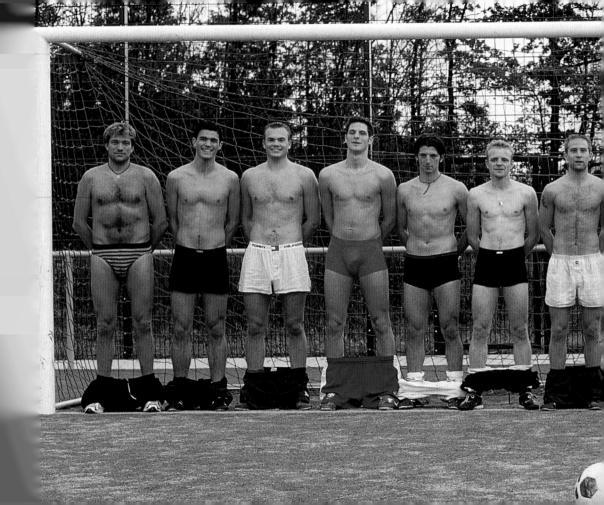

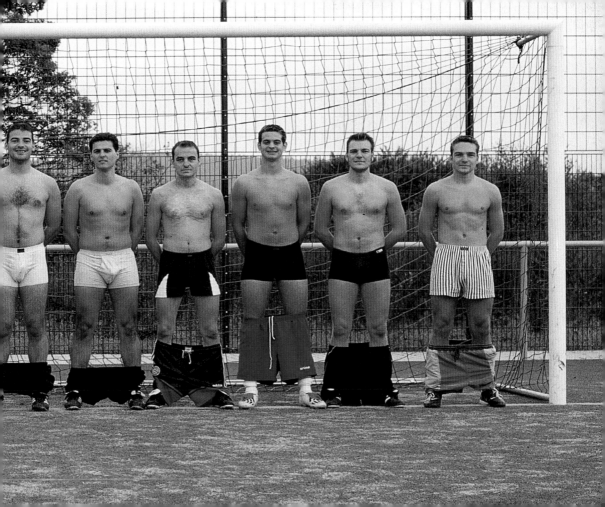

FROM
UNION SUITS

TO
STYLISH BRIEFS

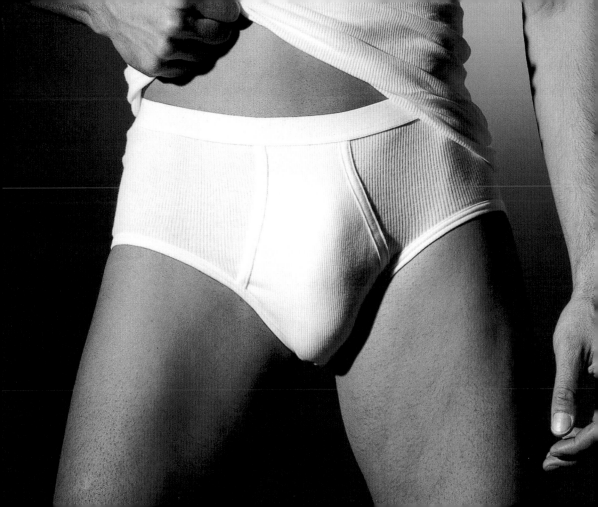

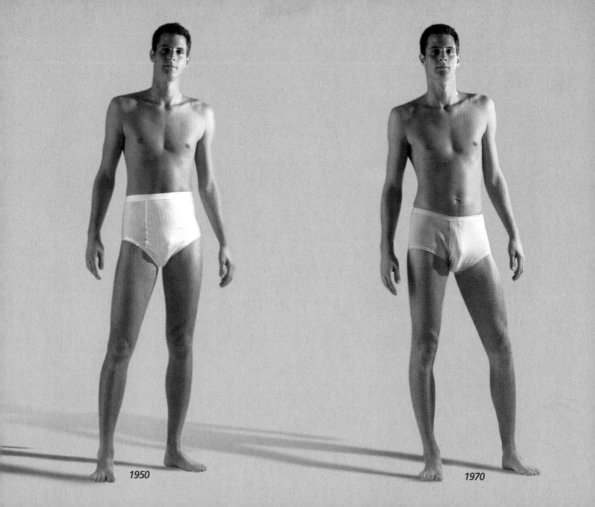

1950

1970

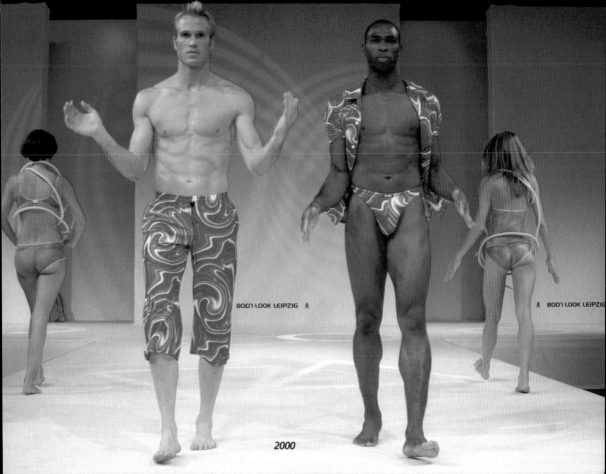

BOD7 LOOK LEIPZIG

BOD7 LOOK LEIPZIG

2000

They are worn from the time one gets up in the morning until going to bed at in the evening. Maybe even at night, with a t-shirt or under pajamas. Underwear is unquestionably an essential component of every wardrobe and performs a variety of functions. First and foremost, it is worn for hygienic reasons. It is changed daily, while jeans or suit pants may not be. It also serves as protection. Underwear holds together what needs to be kept together on a man and provides protection against irritating seams. In addition to its practical usages, however, underwear also plays an important fashion role. In this age of health and well-being, of comfort and consumption, individual freedom, eternal youth and body styling, one's own, everyday outfit has become the true characteristic signature of personality. Everything has to be perfect, from head to toe, top to bottom. This was not always the case. Underwear has not always been something to be taken for granted. And it was certainly not always an item of clothing subject to such intense interest. Nor is the history of underwear as long as many readers may suppose. Underwear had a long way to go before it could cast off its shadowy existence as a mere hygienic necessity in the world of men's clothing and become a true fashion detail

The history of men's underwear is actually much different from that of women's underwear. Men's undergarments consist of an undershirt and underpants, while women have a much larger number of articles: underpants, undershirts, bras, girdles and garter belts just to name a few. Women were always defined by their looks, by their sexuality, while men were defined by their brains. Today, these boundaries have merged. An erotic, attractive outward appearance is a crucial factor for both sexes.

So where do men's underpants – this most intimate and interesting piece clothing – really come from? How did they originate and how long have men been wearing them?

The ancient Egyptians wore a loincloth which covered their private parts and buttocks and was held together by a strap or belt. The Greeks wore a chiton, a shirt-like linen robe, and the Romans a tunica. The Middle Ages saw the advent of "breeches," a piece of fabric with a wrap-around waistband or belt to which stockings were attached. They were all items of clothing, but a distinction between outer garments and underclothing is not possible. Members of the nobility did wear a type of undergarment in the 17th and 18th Centuries, but little is known about it.

A simple shirt, usually made of linen, served as an outer shirt, undershirt, nightdress and underpants for the common people for many centuries. This held true for both men and women. The knee-length shirt was simply gathered up when walking – and presto, one had a pair of underpants. Women wore underskirts as well.

In the 19th Century, industrialization brought with it radical change in social and economic living conditions. This change did not stop at undergarments, and has influenced how we use and regard underwear until this very day. Wearing underpants did not immediately become a standard habit for everyone, however. Initially they were worn by the nobility and the bourgeoisie, while the poor masses long went without wearing anything at all underneath their regular clothing. Amazingly, however, it was well into the 20th Century in some areas before underwear became a matter of course for all social classes and both sexes.

As industrial technologies began developing and the first machines appeared, they revolutionized in particular the manufacture of textiles with spinning machines, mechanical weaving looms and knitting machines. The new technical wonders made it possible to process rough yarns into stretchable tricot fabrics. Later, the invention of the zigzag-stitch machine permitted the creation of pliant seams. The shift in social values and an increasing hygiene awareness and health-consciousness among the population led to the demand for ever softer, more air-permeable underwear. Doctors encouraged the use of more breathable undergarments. Among them was Dr. Gustav Jäger, who had his woolen "Jägerwäsche" patented and sold in all the industrial nations. Jägerwäsche was produced by the then well-known company of Wilh. Benger & Söhne in Stuttgart, which at that time had Jägerwäsche branch stores in Paris, London and New York. Undergarment manufacturers also drew attention to the health aspects of their products.

Industrial manufacturing and mass production finally made underwear affordable for everyone. Cotton increasingly replaced the linen previously used, and the tricot industry began to boom.

Jacques Schiesser, who began his success story in an old dance hall, received the "Grand Prix" for innovation for his company's patented specialties such as braided tricot and vertical-stripe knitwear at the World's Fair in Paris in 1900. Tricot underwear – as a mix of long underpants and under-

*roduction in the USA around 1940

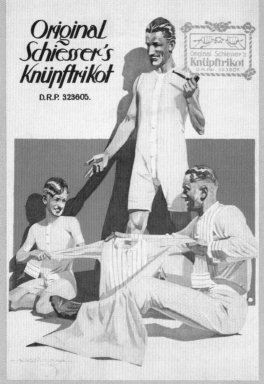

Schiesser button tricots; advertisement from 1913

shirt or as a union suit, first with long legs, later with shorter legs as well – was the most common form of men's underwear until well into the 1920s. In the late 1920s it was even available in daring colors such as – ohlala – purple. Briefs were also becoming a standard form of underwear. Union suits remained popular until well into the 1950s, by the way.

The invention of the first elastic thread, "Lastex," in the late 1920s in the USA improved the wearing comfort and fit of undergarments. Braided lace and button panels vanished. In the mid-1930s, the Heinzelmann company in Stuttgart developed so-called Piccolo underpants, a forerunner of the modern brief for men. The first brief with an upside-down Y which served as the fly opening was introduced to the market in 1935 by Jockey in America. It was a bestseller from the first moment on. Jockey underpants would not become popular in Europe until some twenty years later, however.

The Second World War brought the European textile industry to a nearly complete stand-still. Business owners had to stop production or switch to producing items for military use.

Synthetic fibers such as nylon and perlon, which had only recently been invented, were used to produce war-time materials like parachutes, life vests and rope.

After the war, US soldiers introduced the inhabitants of Europe to boxer shorts, which had been available in the States since the 1920s and had originated as part of the summer uniform for infantrymen. The Germany company Schiesser introduced their legendary fine-rib underwear with fly opening – a model that has been much copied even until today – to market for the first time in 1949. The American company Jockey was also able to successfully market its Y-cut in Europe.

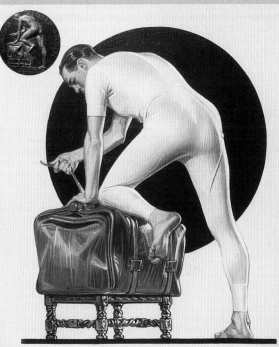

Jockey advertising, would go down in history as:
"Man on the Bag"

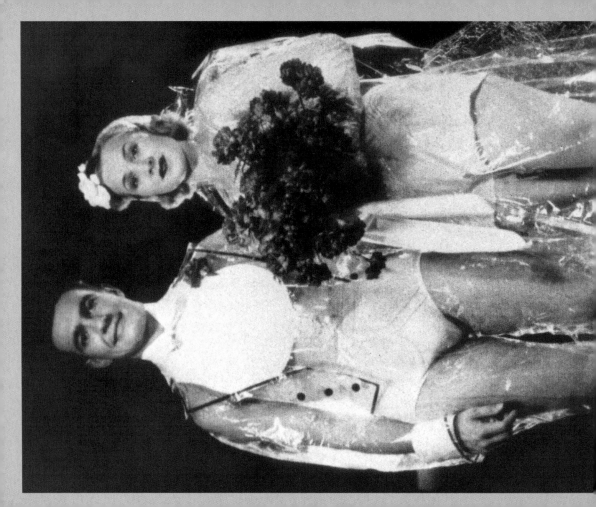

JOCKEY'S "CELLOPHANE-WEDDING"
circa 1935

Jockey created quite a stir with the introduction of its patented Y-front brief in Chicago in 1935. A smiling bride and groom appeared in a see-through dress and tuxedo made of cellophane. Not only was the Y-front brief a smash success, this Jockey presentation was also the world's first public underwear show!

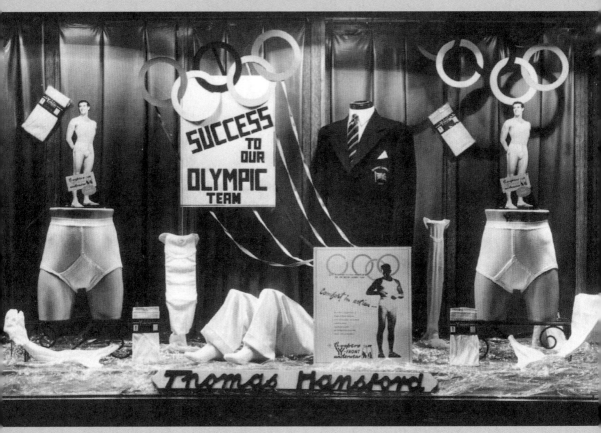

The Y-front brief from Jockey; the official outfitter of the British team for the Olympic Games in London in 1948.

In the **1950s**, the European reconstruction program, the Marshall Plan, promised an economic upturn and with it luxury and improved quality of life for everyone. It was a time of hope and belief in progress, hallmarked by a cult of cleanliness that was expressed in the feeling of well-being offered by the new synthetic fibers such as viscose, nylon and perlon. All of these materials promised increased durability, easy care and quick drying. In terms of men's underwear, however, this decade did not bring with it anything that could have possibly aroused the emotions.

The **1960s** were a decade of generational conflicts and student revolts, and their influence continues to make itself felt until today in culture, society and politics. This era could do nothing to harm the standing of men's underwear, however. Simple underpants with a fly opening survived even these rebellious years. The late 1960s brought with them bikini briefs for men. Underpants became smaller and the waistband dipped dangerously low beneath the bellybutton. These tight but nonetheless plain cotton pants were usually worn in pastel colors – a tiny foretaste of what was to come in the following decade.

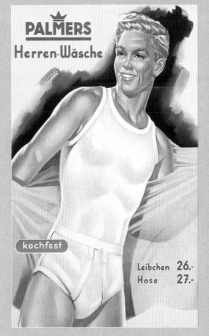

PALMERS
Herren-Wäsche

kochfest

Leibchen 26.–
Hose 27.–

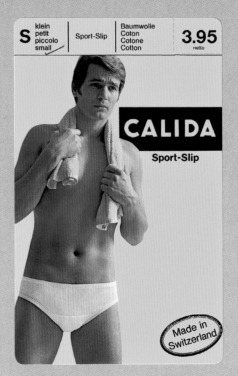

| S | klein
petit
piccolo
small | Sport-Slip | Baumwolle
Coton
Cotone
Cotton | **3.95**
netto |

CALIDA

Sport-Slip

Made in Switzerland

In the 1960s, fashionable briefs became smaller and the waistband dipped below the belly button; Calida briefs from late 1960s.

The radical changes which began in the 1960s gained a firm foothold in the **wild 1970s**. And they brought with them new waves of color in the world of men's underwear. Traditional conventions and taboos were finally banished and young people rejected self-satisfied, middle-class respectability once and for all. The break with the past was also expressed in underwear design. Nothing was too colorful, no print was too much.

The entire color spectrum and models of every kind imaginable were to be found in this decade. Two-colored underpants in typical combinations such as blue/brown or orange/green, as well as checks, stripes and flowered cotton briefs, were all the rage.

The **1980s** were the most innovative decade of the century for men's underwear. There was revolutionary upheaval and astounding variety. There were many reasons for this development, but one is no doubt the growing self-confidence of the gay pride movement.

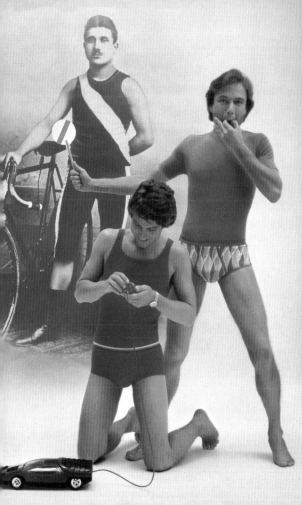

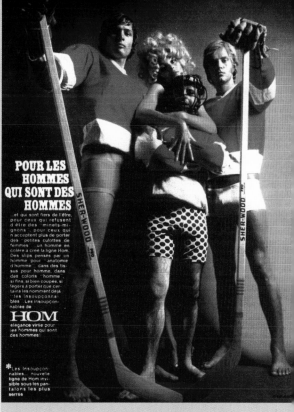

Underwear sets from HOM

Lots of color and a variety of prints were a hit in the 1970s.
Schiesser models from circa 1970.

Andy Warhol, king of pop art.
He designed the cover of the Rolling Stones album Sticky Fingers. A special feature: a real zipper that offered a glimpse of a pair of underwear when opened. Warhol personally preferred the classic Jockey briefs.

The protest movements of the previous years had subsided, economic crises had been overcome. The desire for naturalness, informality and freedom gave way to the striving for "visible" success, and focus once again shifted to material objects and goals. A man's status was no longer determined chiefly by his life experience and his intellect. The body had become the new status symbol, outward appearance was now the key to success. Both men and women derived their self-confidence from the purchase of must-have designer clothing – the yuppie was born. It was the era of the body cult, in which one steeled one's body at the gym and packaged it accordingly. The developing brand awareness became a true label cult and made itself evident in all facets of life – one need only to call to mind Guess jeans and Swatch watches. For the first time ever, men's underwear now became a serious fashion issue – and underpants, previously little heeded and regarded as nothing more than a basic necessity – gradually became a prestige article.

Wide elastic waistband and high-cut leg holes – tanga model from the 1980s

The marketing experts in the undergarment industry began brainstorming about how this basic article could best be sold to men, but impulses came from an unexpected source.

In the mid-1980s, the Greek designer Nikolaos Apostolopoulos created quite a stir when he introduced tight briefs with high-cut legs and a wide waistband in black, a previously unthinkable color. Sexy underwear in black became socially acceptable.

With eroticism as the core of his work and a mix of sexuality, body cult and perfectly staged ad campaigns, Calvin Klein effectively turned the world of men's underwear upside down. Klein's portrayal of erotic male beauty unleashed a whirlwind of emotions. Over-dimensioned advertising posters showed athletic, perfectly shaped male bodies in simple, white, extremely well-filled briefs with a broad elastic waistband bearing the designer's name. Underwear became a true object of desire and fine rib – turn-off – became the ultimate collector's item. Klein's campaign also turned models into stars. Until then virtually unknown, Mark Wahlberg became a Hollywood star overnight. Kate Moss made her breakthrough to become an international supermodel.

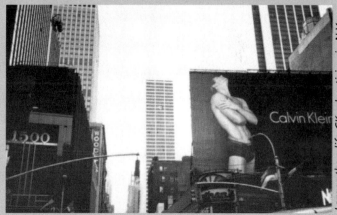

Larger-than-life CK advertising in N.Y.

The bestseller of the 1980s, however, was boxer shorts. Adorned with discreet stripes, checks, covered with popular comic figures, bunny rabbits, kisses or Santa Clauses, they became the ideal present for every occasion.

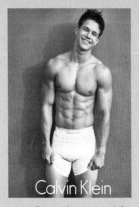

Mark Wahlberg became a Hollywood star overnight thanks to the Calvin Klein campaigns.

A striving for recognition, a tendency towards materialism, a penchant for eroticism and eternal, athletic youth continued in the 1990s – with daily vitamin drinks, face and body lifting and of course Viagra. The bathroom cabinet was soon filled with body lotions and eye creams for him. And men's underwear continued to reap the benefits of the booming fitness and body cult.

It was the decade of globalization and information overload, in which borders disappeared and a desire for security and new values arouse. While the consumption mindset flourished, the search for deeper meaning began as well. In their striving for self-perfection, men looked for underwear that corresponded with their way of thinking and living, identifying themselves with brand names and the associated lifestyles. Underwear now combined functional and athletic elements, elegance and individuality. A designer name on the elastic waistband of underwear became extremely popular. The demand for luxury brands increased. In the early 1990s, Wolfgang Jassner and Klaus Jungnickel introduced timeless underwear in classic colors and sporty chic under the brand name bruno banani. It soon became a lifestyle label, with brand marketing that included limited collector's editions and spectacular brand presentations.

Whether made of pure cotton or high quality material blends – the world of men's underwear in the early 21st Century offers no lack of excitement. The men's undergarment market is crowded with a multitude of manufacturers and labels. No longer confined to their functional aspects and usage alone, men's underwear has long since become the most interesting piece of a man's wardrobe and an indispensable fashion accessory. Whether for the fashion-conscious trend-setter, the sports enthusiast, the lover or the down-to-earth type – underwear is available in any conceivable shape, leg length, materials or color design, as well as in plain black and white and the omnipresent retro-look.

Comfort and well-being, individuality and functionality, sporty charm and erotic appeal – today's men's underwear fulfills all these demands and makes men look good in the process – if they want it to!

A man should know his measurements in order to make sure that his underwear fits perfectly. The circumference of the hips and waist are the key measurements in determining the right size. To take a measurement, the measuring tape is simply wrapped around the largest point of the hips.

MALE M

There are no set sizes, meaning that sizes often vary from manufacturer to manufacturer. When buying underwear made of fabrics which tend to shrink, one should consider buying them one size too large.

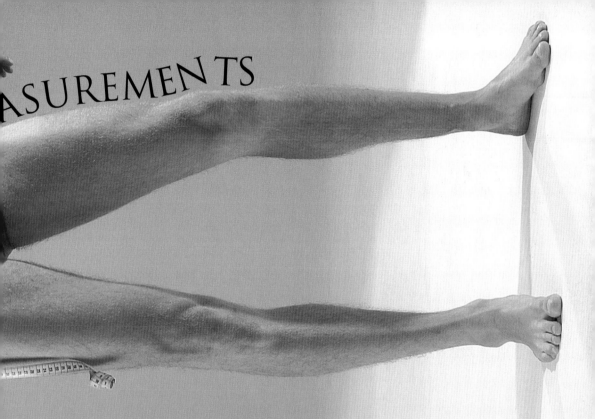

ASUREMENTS

Waist and hip circumference in cm

	76-80	81-85	86-91	92-97	98-103	104-109	110-115	116-123	124-135
Size	XS	S	M	L	XL	XXL	3XL	3XL	4XL

THE BRIEF

In 1934, the Heinzelmann company in Stuttgart introduced so-called "Picollo briefs," a forerunner to the modern version. Jockey introduced its world-famous Y-brief to market in 1935. A hit right from the start in America, the Y-brief did not become popular in Europe until some 20 years later.In 1949, the Schiesser company gave the world its legendary fine-rib brief.

The brief is available in a wide variety of shapes and cuts.
The classic brief is relatively compact and wide and has a fly
opening. It ends at or just below the belly button and has a
modest leg hole. The back is generously cut.

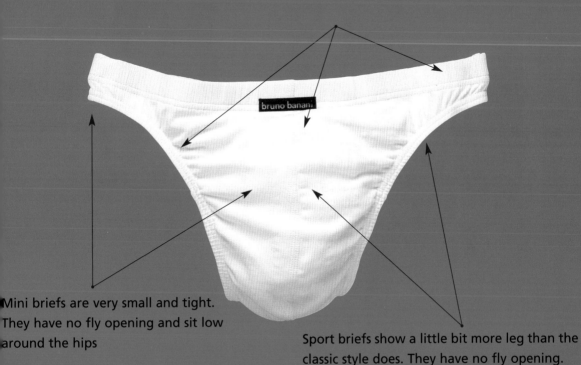

Mini briefs are very small and tight.
They have no fly opening and sit low
around the hips

Sport briefs show a little bit more leg than the
classic style does. They have no fly opening.

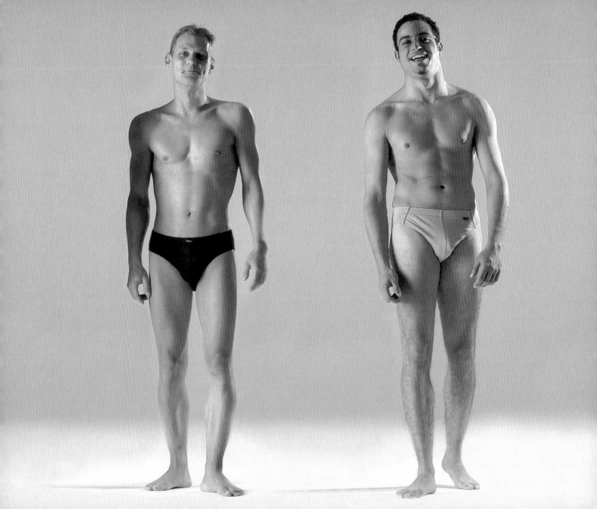

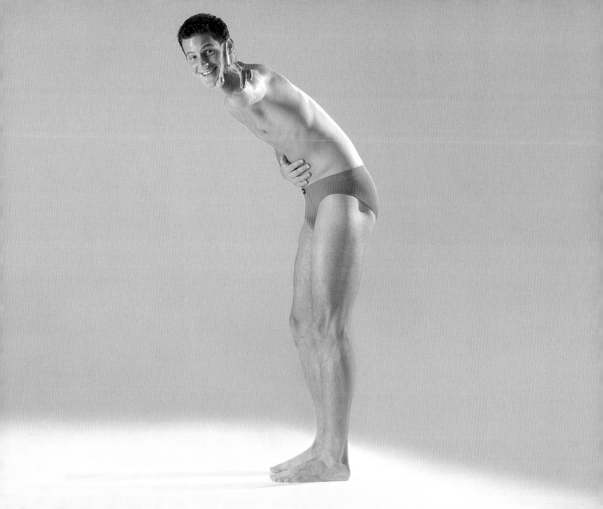

BASICS

Quelle

Bruno Banani

Mey

BASICS IN

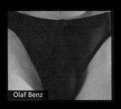

Olaf Benz

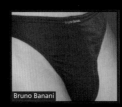

Bruno Banani

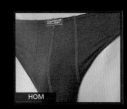

HOM

IN WHITE

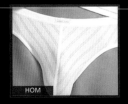

HOM

Body Art

Calvin Klein

BLACK

Bruno Banani

Mey

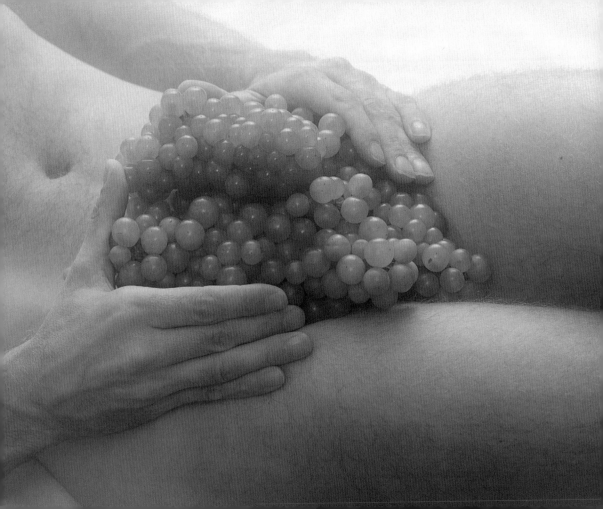

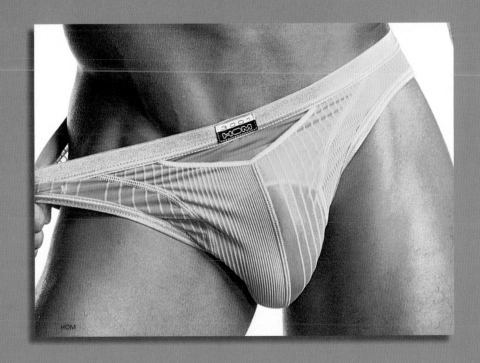

HOM

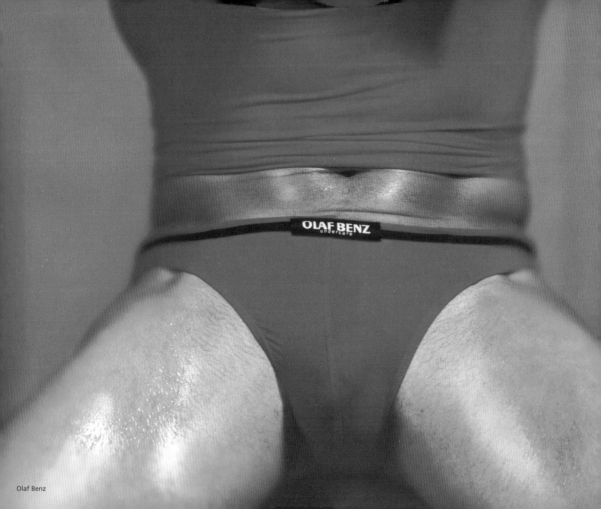

Olaf Benz

ckey

Mey

Schiesser

ersace

Wolff

Eros Veneziani

HOM
HO!
HOM

ΣΡΘS
VENEZIANI

SCHIESSER

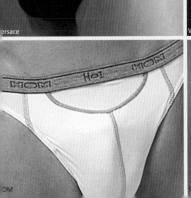

DM

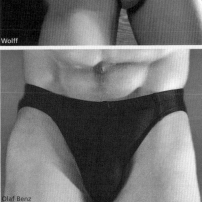

Olaf Benz

Olaf Benz

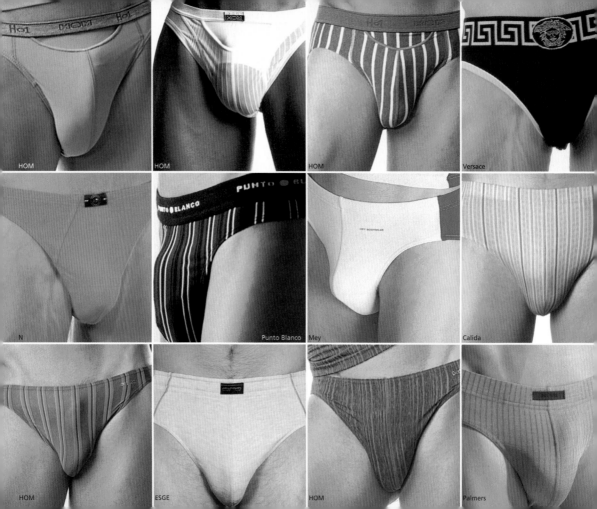

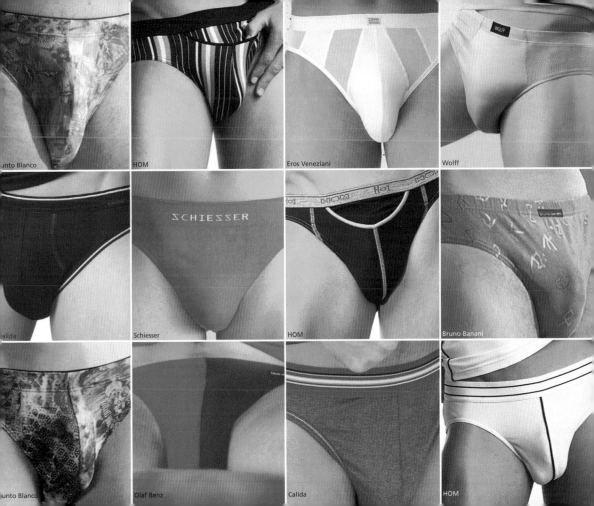

unto Blanco

HOM

Eros Veneziani

Wolff

alida

Schiesser

HOM

Bruno Banani

unto Blanco

Olaf Benz

Calida

HOM

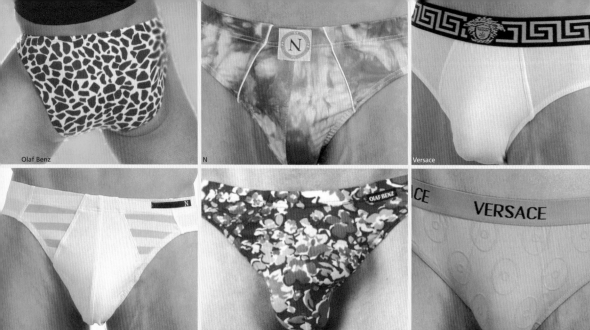

Olaf Benz

N

Versace

N

Olaf Benz

Versace

L'homme invisible

HOM

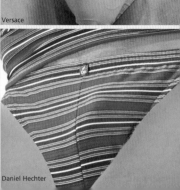

Daniel Hechter

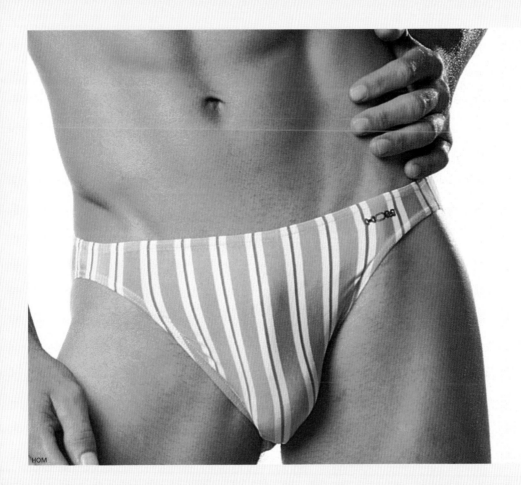

HOM

THE TANGA

The word "tanga" is Portuguese and means loincloth.

he classic tanga has little fabric. The sides consist
f nothing more than the waistband.

The high leg holes permit lots
of freedom of movement

ike briefs, the back is gene-
ously cut so that the buttocks
well packaged.

The string tanga has less fabric in
the back than the classic tanga,
leaving the buttocks uncovered.

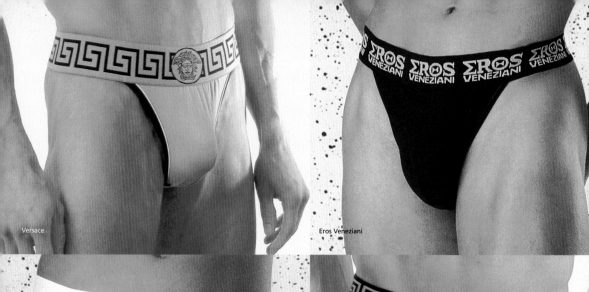

Versace

Eros Veneziani

Eros Veneziani

Versace

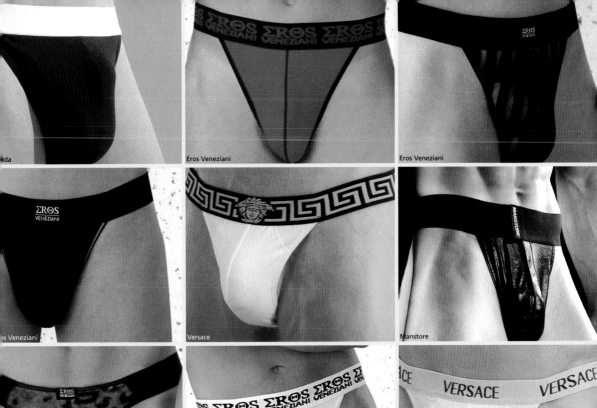

ida

Eros Veneziani

Eros Veneziani

os Veneziani

Versace

Manstore

os Veneziani

Eros Veneziani

Versace

DeR sChöNste GRunD,
abzuNehmEN:
EiN WiEdeRsehEN mit MeY.

mey
fine bodywear

STORIES FROM
THE WORLD OF UNDERWEAR

Brands
Profiles
Designers

BRUNO BANANI, GERMANY

Founded in 1993 by Wolfgang Jassner and Klaus Jungnickel, bruno banani began with simple, timeless underwear. The brand, which regards itself as a culture and picks up on the latest trends, very quickly became a success. The company has meanwhile expanded its portfolio.

From Hong Kong to Moscow to Johannesburg, it now offers stockings, eyeglasses, shirts and a series of perfumes as well as men's and women's undergarments.

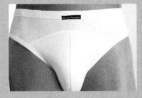

The hallmark of bruno banani is a its markedly young presentation as an unconventional lifestyle label, limited editions for collectors and unusual brand presentations: bruno banani tests its underwear during ultranautical deep sea expeditions, spectacular missions to the MIR Space Station and at high speeds in the electronuclear particle accelerator at the Research Center in Jülich. In addition to simple, purist undergarments, the range also includes lines in bright colors and striking prints.

bruno banani

WOLFF, AUSTRIA

From the development of the fabrics all the way to the finished product – Gebrüder Wolff GmbH offers everything from a single source and is an international success. The company's main markets are Europe, the USA and Japan.

Johann Wolff founded a hosiery factory in Vorarlberg in 1926 to produce knit goods. Eight years later, he expanded the company to include a knitwear factory. Ready-to-wear manu-

facturing for men and women was introduced in the 1950s and dyeing and finishing in the mid-1960s.

The full-service company is active in various sectors. In addition to underwear and bodywear for men and women under the Wolff label, the company acts as a supplier for large customers as well, producing fabrics for the foundation garments and clothing industry and for special uses. Wolff also works together with international designers.

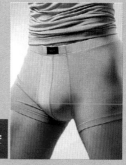

CALVIN KLEIN, USA

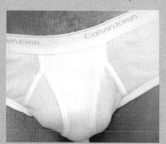

Calvin Klein, the pioneer of designer underwear, designer jeans and the all-American look, is regarded as a lifestyle marketing genius. The designer has received numerous awards, including being named "Best American Designer" in 1993.

Born in 1942 as the son of a grocer in the Bronx in New York City, he taught himself how to draw and sew as a child. He later attended New York City´s High School of Art and Design and the Fashion Institute of Technology. At age 26, he founded his own label together with his old friend Barry Schwartz.

In the 1980s, when marketing was more important than creativity in the fashion design industry, Calvin Klein turned the world of men's underwear upside down with hard-driving marketing power and spectacular ad campaigns. He placed his name on the elastic waistband of fine-rib underwear with fly – a former turn-off – suddenly bringing it new popularity.

HANRO, SWITZERLAND

Whether for nightwear or daywear, Hanro offers its male and female customers the latest trends expressed in classic, sophisticated styles, with uncompromising use of the finest materials and in the highest quality standards.

The company's history began with Albert Handschin, who founded his first hand-knitting factory for underwear in Liestal in 1884. At the turn of the 20th Century, the company had 160 employees and became a general partnership belonging to Albert Handschin and Carl Ronus. Hanro has been a registered trademark since 1913. The name is a combination of the first syllables of the founders' names. A luxury brand with an international reputation, the core of Hanro's product portfolio is formed by classic undergarments in the upper price category. The company has been a part of Huber Group since the early 1990s.

HANRO

SCHIESSER, GERMANY

Fine rib with fly and Schiesser – two names which are inseparably linked with one another and are extremely well known in the undergarment industry. Schiesser develops, produces and markets daywear and nightwear undergarments for men, women and children as well as lingerie, homewear, swimwear, baby cloth and functional sportswear. Schiesser introduced its legendary fine-rib look to market in 1923.

The company's success story began in 1875 in a dance hall in the *Zum Schwert* inn in

Radolfzeller, where Jacques Schiesser and his wife Malwine produced knitted fabrics on nine circular knitting machines. The company already enjoyed worldwide recognition at the turn of the 20th Century. The Second World War brought with it emergency programs, including war production, and the now well-established Schiesser fashions became a victim

of the war. There was a new economic upswing from the 1950s onward, and Schiesser went on to become one of the largest and best known textile manufacturers in Europe.

In company headquarters in Radolfzell on Lake Constance, Schiesser now focuses on product development as well as on marketing and sales activities. The production of the collections takes place in the company's own factories in Germany (equipment), the Czech Republic, Slovakia, Bulgaria and Greece as well as through authorized third parties. In addition to classic Schiesser underwear, the company also offers various lines and styles in creative designs and trendy materials, thus effectively building a bridge between tradition and modernity... "so that as many people as possible feel good just being themselves."

SCHIESSER

EROS VENEZIANI, ITALY

The Eros Veneziani collection from the designer of the same name was first introduced to the public nine years ago. Designed and produced entirely at the company's facilities in the Italian mountains near Lago d´Iseo, this underwear conveys Italian charm and lifestyle. The

collection includes the Uomo line for men and the Donna line for women.

The company itself has existed for 20 years. Production used to occur on an order basis. The friendship between the company owner and the designer Eros Veneziani made possible the development of an independent undergarment collection. Eros Veneziani underwear quickly became a well known brand in the company's native country of Italy and has been available throughout Europe, America and Asia for three years.

ΣRΘS
VENEZIANI

CALIDA, SWITZERLAND

The strength of its own brand is the key to the success of Calida Bodywear. The traditional Swiss undergarmentmaker has a market-oriented corporate structure and cultivates core competencies such as product quality and operative efficiency. Its strategy is the develop-

ment of new product lines such as loungewear and functional undergarments under the ACTIVE & AIR label, the promotion of franchises and shop-in-shop concepts as well as a broad communications front. The company's history began in 1858 with the founding of a small manufacturer in Sursee. The CALIDA brand was introduced by the two founders, Max Kellenberg and Hans Joachim Palmers, in 1941. The most important sales market outside of Switzerland is Germany. The portfolio encompasses undergarments for the entire family. The product spectrum ranges from elegant daywear and nightwear all the way to young, sporty models. What can a man expect of Calida? "CALIDA men's underwear is straight, structured and has no fancy frills."

CALIDA
BODYWEAR

BODY ART, GERMANY

At the foot of the Swabian Mountain in Bisingen, the young company G + M Textil GmbH develops, produces and markets the undergarment brand Body Art and KAPART for today's man.

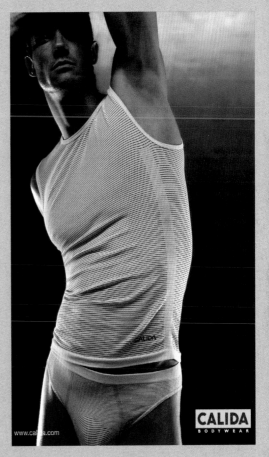

www.calida.com

CALIDA
BODYWEAR

The two lines are very different from one another and cater to the needs of very different target groups. Underwear and swimwear from Body Art is for the fashionable man who is searching for something special to go "underneath," in keeping with the motto "Create your Body with Body Art." The KAPERT brand offers a range of normal to extra-large sizes

for standard underwear as well as pajamas in fine cotton.

G+M Textil GmbH was founded in 2002, although the two brands were taken over from the traditional Maute GmbH company which had gone bankrupt. The underwear is sold throughout Europe.

MEY, GERMANY

Mey, fine bodywear is a traditional company that produces quality undergarments. Many of the cuts and patented developments from Mey have started trends in the underwear market. Founded in 1928 by Franz Mey as a commission knitwear factory, the family-owned company has became one of the leading manufacturers in the undergarment industry. Mey places special emphasis on details. Cuts are created and perfected with the help of computer-aided procedures, the setting of the seams is electronically controlled. Mey has been producing men's underwear since the 1980s. Today, the company employs a workforce of approximately 900 in factories in Germany and Portugal.

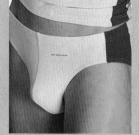

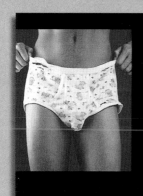

ViELe MäNNeR veRhütEN, oHNe eS zu woLLeN.

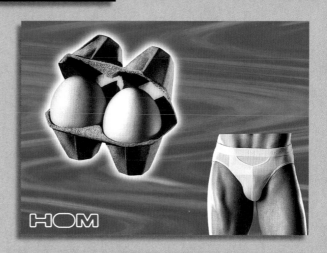

HOM

61

HUBER, AUSTRIA

Producing "underwear you feel good in" is the primary goal of this company. It thus comes as no surprise that HUBER sees itself as a family-brand and has been producing classic undergarments for men and women as well as fashionable, sporty underwear for children for more than 100 years. Huber Tricot GmbH has been one of Austria's best known brand manufacturers since its founding. Huber Tricot GmbH is a part of Huber Holding AG.

SKINY BODYWEAR, AUSTRIA

Skiny Bodywear GmbH is also a part of Huber Holding. Just like Huber Tricot GmbH, Skiny stands for quality undergarments from Austria and is oriented to a clearly defined customer group. The brand is known for young, sporty, trendy underwear and beachwear and has an international presence. Its main market is Europe, while Mexico is a license market.

RÖSCH, GERMANY

The undergarment specialist Gerhard Rösch GmbH from Tübingen caters to up-market demands. It began the production of polo shirts and men's shirts as well as perlon underskirts in 1949. The main factory in Tübingen was established in the 1950s. The subsidiary Rökona was founded a short time later and produces materials for the parent company and other sales markets. RÖSCH brought out its own swimwear and casual collection in 1970. With

locations in Germany, France and Hungary, Rösch offers homewear as well as nightwear and daywear undergarments for its customers worldwide.

RÖSCH
CREATIVE CULTURE

PALMERS, AUSTRIA

This history of Austria's largest textile corporation, which offers undergarments for the entire family, began with the opening of the first Palmers store in Innsbruck in 1914.

With a reputation that extends far beyond the borders of the small Alpine country, the company has made an international name for itself, employs a workforce of 1,860 and has branch stores in Austria and abroad in countries such as Greece, Italy, Turkey and southeastern Europe. Palmers has a total of 120 locations in 21 countries.

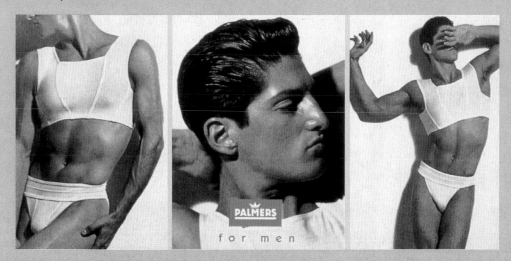

The company improved its popularity and image in the 1980s when it began a new advertising campaign that attracted great attention in Austria with an unusual poster series. Some posters in the series have become classics.

PALMERS

PUNTO BLANCO, SPAIN

The label Punto Blanco from sunny Spain is exceptionally popular. Nor is its popularity limited to Spain alone. The brand from Industrias Valls 1, S.A., is the leading label in its home country of Spain and one of the top names in Europe. It is sold in over 30 countries worldwide. The company from Barcelona has been in existence since the early 20th Century. The Punto Blanco brand was created by D. Pedro Valls in 1948. Equally striking and sensual as well as flattering, the label offers bodywear and underwear for trend-conscious men and women.

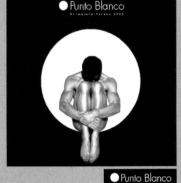

● Punto Blanco

ESGE, GERMANY

ESGE, the underwearmaker! Family-owned for four generations, the company has been producing undergarments since 1881.

The full-service operation handles material manufacture, equipment, printing and packaging. Production takes place in Greece, Portugal, Bulgaria, Romania and Turkey. Exports are sent to Central Europe as well as Turkey and Russia. ESGE offers undergarments in the mid-price segment for men, women and boys.

NIKOS APOSTOLOPOULOS, FRANCE

The Greek multi-talent Nikos, a fashion designer and lawyer, began his eventful career in the mid-1980s with daring men's undergarments. The tight fits and dramatic effects were the subject of much attention. The guiding principle of his first collection was turning the body into a perfect figure. Nikos draws his inspiration from Hellenic mythology. In addition to underwear, the designer also creates jewelry and perfume.

HOM, FRANCE

"Innovation Pour Elegance Masculine" – In 1968, Charles Belpaume and Gilbert Anselme founded the textile company IPEM in Marseille and created the exclusive HOM brand for the fashionable man. The ingenious Frenchmen quickly made a name for themselves in the top rankings of the undergarment and swimwear sector. And what works underneath can also work on top – so the collection was soon expanded to include outerwear as well. HOM has meanwhile established itself as a brand in more than 80 countries and on five continents. HOM – fresh and provocative, humorous and with a touch of frivolity – has been a pioneer of a number of new creations and concepts in the world of men's underwear over the cour-

se of its successful history. The patented brief concept HO1 (a brief with a horizontal fly opening) and the accompanying advertising campaign attracted lots of attention.

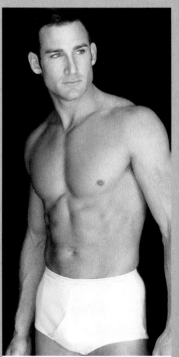

HOM

JOCKEY, USA

Jockey Inc., a company with an impressive history behind it, is one of the world's leading and best known manufacturers of fashionable undergarments for men, women and children. Found by the American clergyman Samuel Thrall Cooper as a hosiery factory in 1846, Jockey made the transition to become an undergarment manufacturer at the beginning of the 19th Century.

The company has introduced a whole row of innovations and new products to the undergarment market. Jockey made history, however, with the Y-front brief that was introduced to market in 1935 and enjoyed record-breaking success. The patented model became one of the best-selling cuts. It has been copied innumerable times and has served as the basis for many other models. The American company began selling licenses worldwide starting in 1936, initially in England, Australia and New Zealand. Today the company has a total of 120 license holders worldwide.

the next best thing to naked™

JOCKEY

The Quintessential Brief By Jockey

OLAF BENZ, GERMANY

Olaf Benz's target group is young, intelligent, as well as fashion- and body-conscious and interested in parties and events. Everything centers on the motto "only those who dress themselves well can also undress themselves well." The collection was started by the designer Alfons Kreuzer. It has been on the market since 1988 and is available worldwide. Young people are particularly important to the designer, not just as customers, but as employees in a future-oriented company. He thus established a virile team of eight young people as impulse providers for the collection and a presentation appropriate to the target group.

OLAF BENZ

MANSTORE, GERMANY

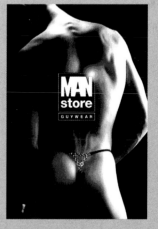

The cult label Manstore Guywear has already created a furor on the international market once before in the 1970s with spectacular men's underwear. Initially, the styles were created by the French star designer Paco Rabanne, who invented the first men's string among other things. The label was later taken over by designer Hans Schöller. After his death in 1995, the trademark rights were acquired by Alfons Kreuzer, who continued the design line. The Manstore target group is extremely fashion-conscious and is looking for eccentric details in cut, material and color.

LONG UNDERWEAR

Often with a covered fly opening, but sometimes without one

Elastic waistband

Although they provide warmth on cold days, some men don't like to admit wearing them. Yet long underwear that is well designed and fits perfectly it is quite chic.

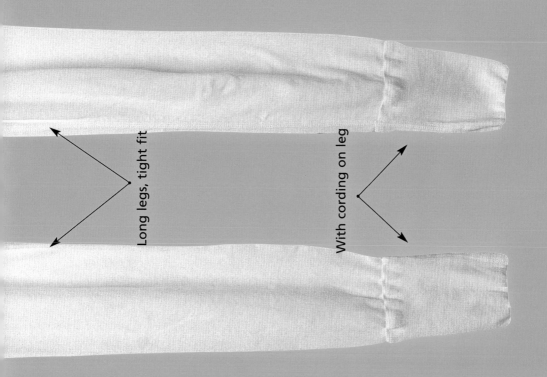

Long legs, tight fit

With cording on leg

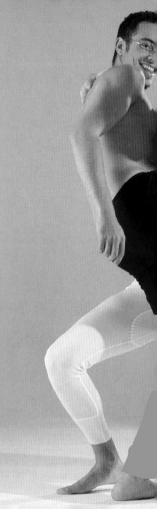

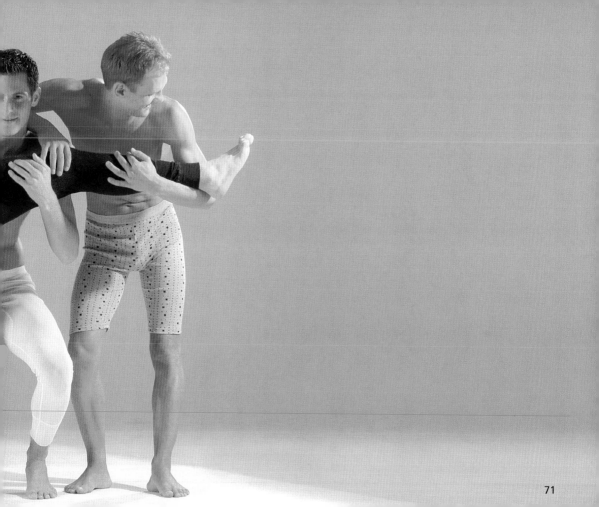

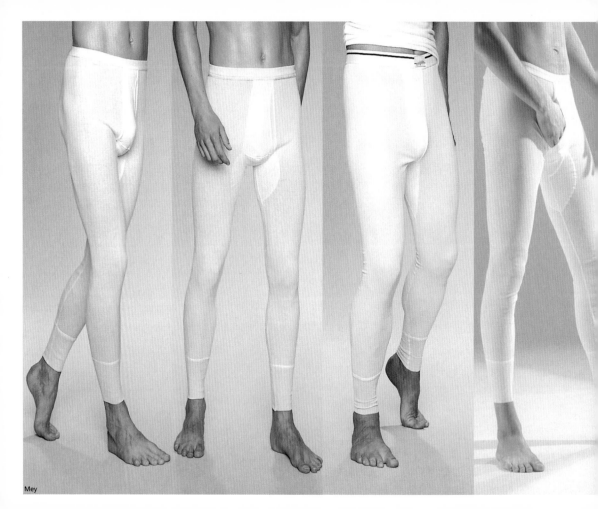

Mey

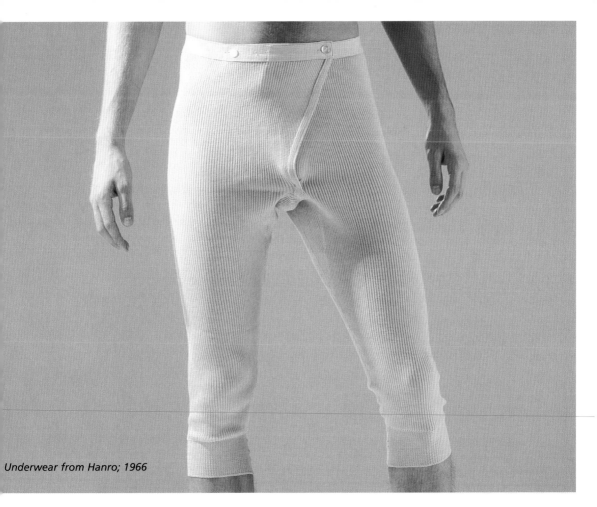

Underwear from Hanro; 1966

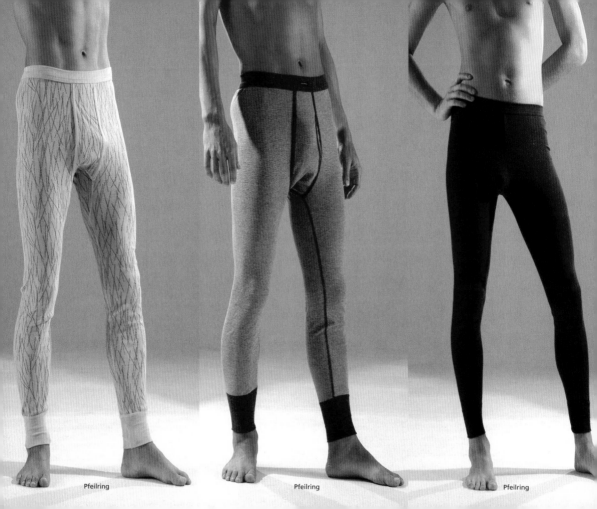

Pfeilring

Pfeilring

Pfeilring

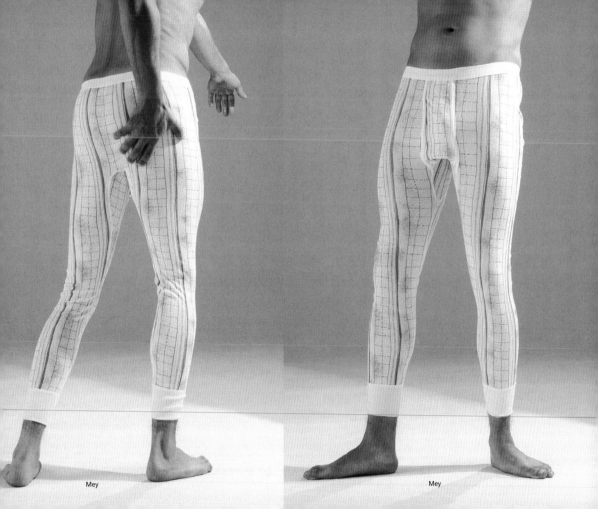

Mey

Mey

PANTS

Tight-fitting underwear that ends in a straight leg line.
In contrast to boxer shorts, hot pants have no leg piece.

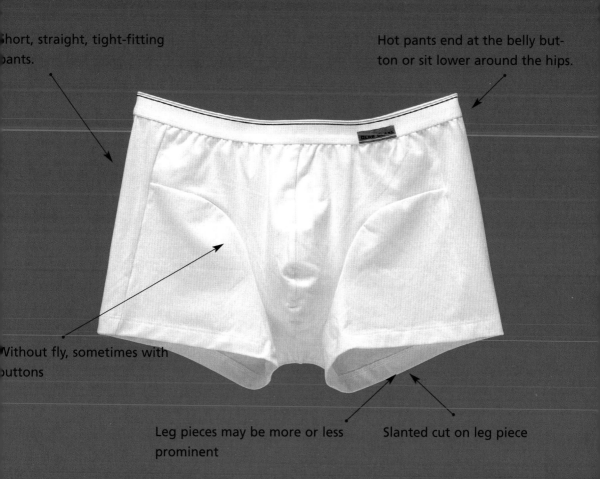

Short, straight, tight-fitting pants.

Hot pants end at the belly button or sit lower around the hips.

Without fly, sometimes with buttons

Leg pieces may be more or less prominent

Slanted cut on leg piece

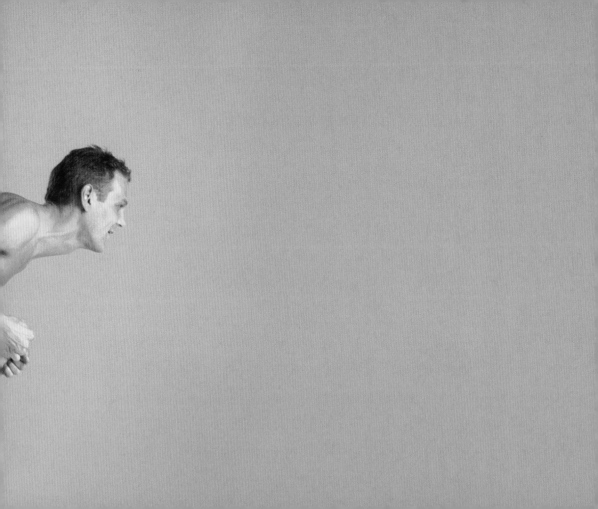

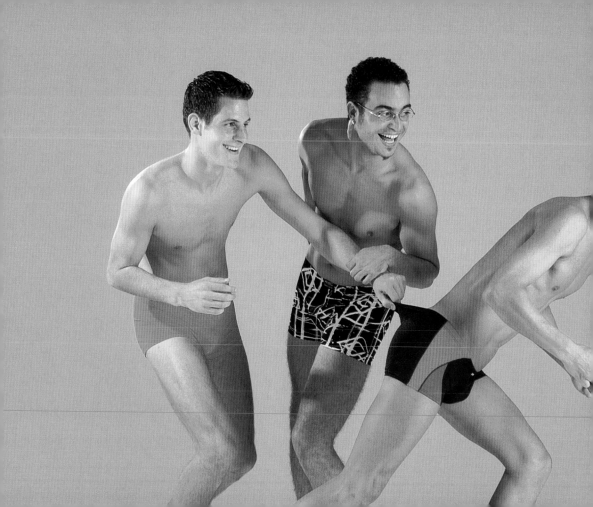

BASICS

Calvin Klein

Bodyart

BASICS IN

Mey

Calida

IN WHITE

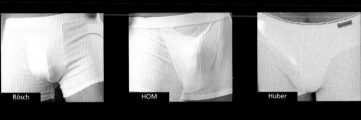

Rösch HOM Huber

BLACK

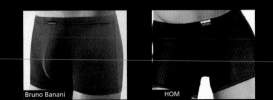

Bruno Banani HOM

Andrea Pozzo, apotheosis of Hercules, 1704 - 07, ceiling fresco in garden palace Lichtenstein, Vienna

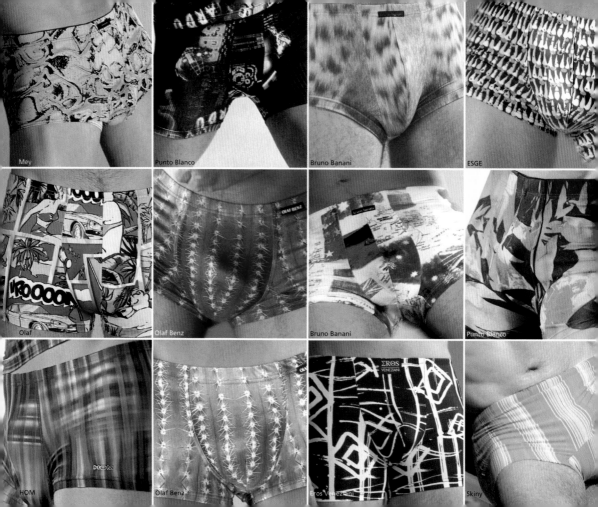

Mey

Punto Blanco

Bruno Banani

ESGE

Olaf

Olaf Benz

Bruno Banani

Punto Blanco

HOM

Olaf Benz

Eros Veneziani

Skiny

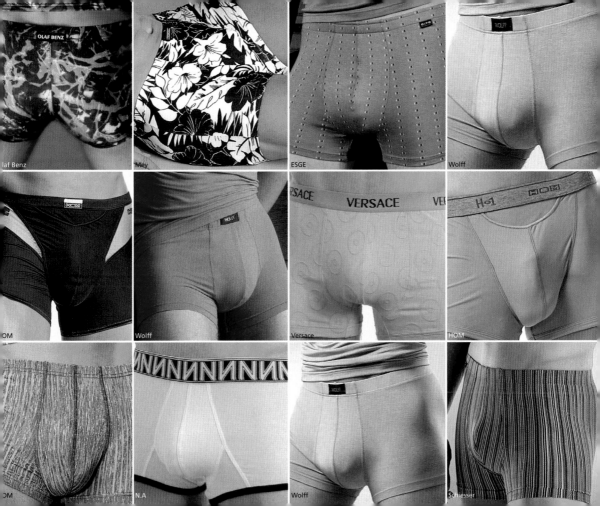

Olaf Benz

Mey

ESGE

Wolff

OM

Wolff

Versace

HOM

OM

N.A

Wolff

Schiesser

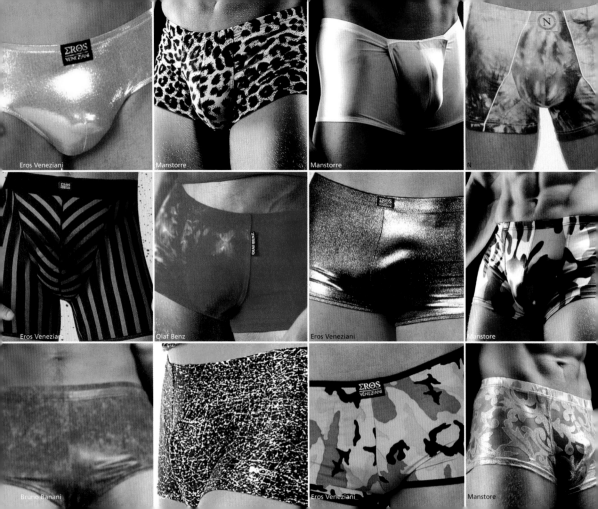

Eros Veneziani

Manstorre

Manstorre

N

Eros Veneziani

Olaf Benz

Eros Veneziani

Manstore

Bruno Banani

Eros Veneziani

Manstore

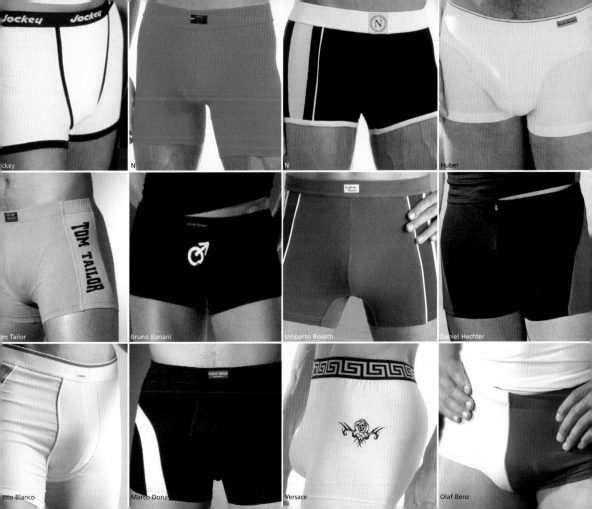

ckey

N

N

Huber

m Tailor

Bruno Banani

Umberto Rosetti

Daniel Hechter

nto Blanco

Marco Dona

Versace

Olaf Benz

HOM

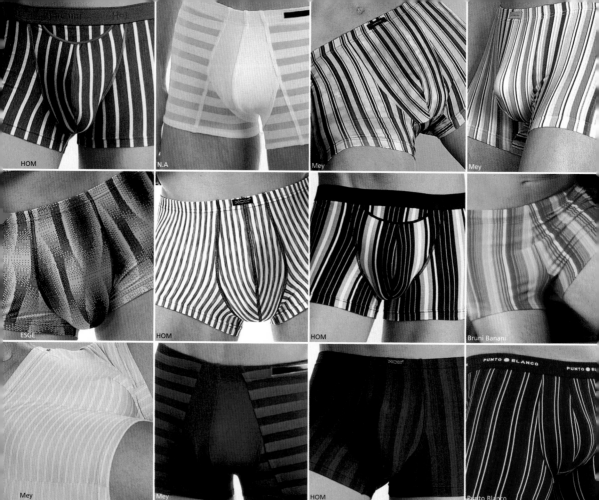

HOM

N.A

Mey

Mey

ESGE

HOM

HOM

Bruni Banani

Mey

Mey

HOM

Punto Blanco

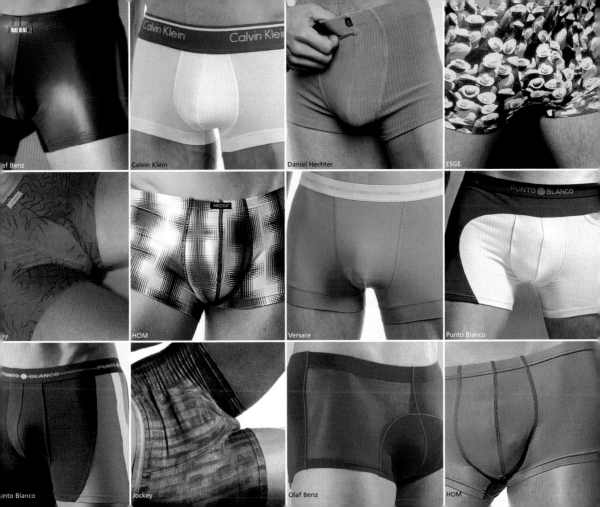

af Benz

Calvin Klein

Daniel Hechter

ESGE

HOM

Versace

Punto Blanco

nto Blanco

Jockey

Olaf Benz

HOM

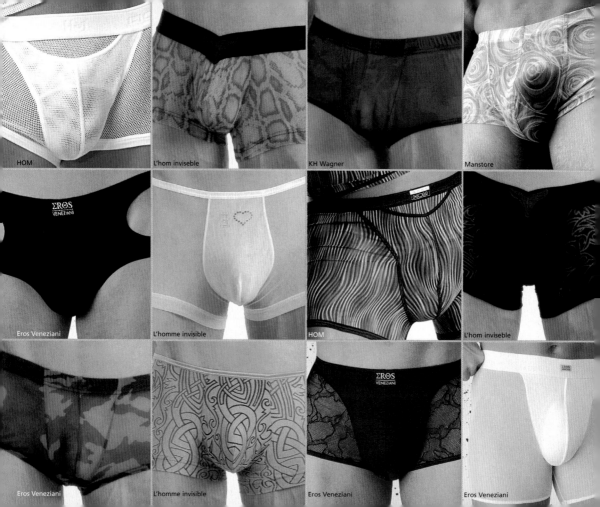

HOM

L'hom inviseble

KH Wagner

Manstore

Eros Veneziani

L'homme invisible

HOM

L'hom inviseble

Eros Veneziani

L'homme invisible

Eros Veneziani

Eros Veneziani

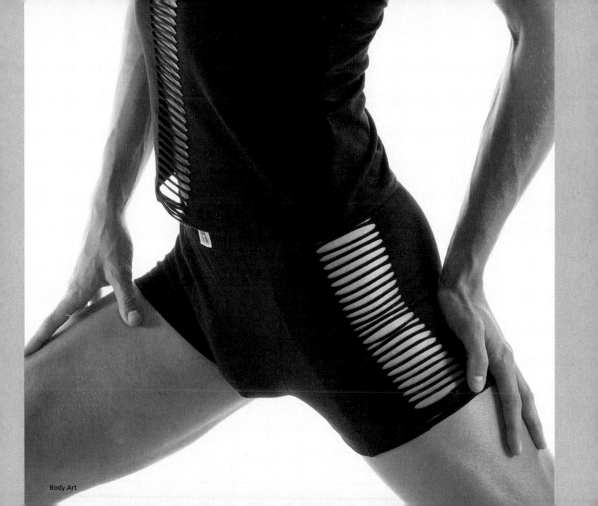

Body Art

THE STUFF

OF WHICH OUR

UNDERWEAR IS MADE

Cotton, Lycra®, Tactel®, Tencel®, viscose – these are the fibers of which our underwear is made. Of course everyone is familiar with cotton, but the layperson may have more difficultly identifying the newer fabrics.

Cotton is in fact one of the most important cultivated plants on earth and is the most prominent textile raw material in the world, composing a 40% share of all fibers used in the textile industry. In 1950, however, this figure was still approximately 80%. An important factor in the decreasing percentage of cotton in textile production is the continuous development and manufacture of new fibers. The resulting fabrics are functional, environmentally compatible, have the best wearing characteristics, feel good and are easy to care for. The various positive characteristics of the individual fibers can be optimized by purposefully blending them with different fiber groups. Cotton, for example, is often blended with elastic fibers due to its low stretchability.

A basic distinction is made between natural fibers and synthetic fibers. The unique feature of synthetic fibers is that their composition and structure – and thus their characteristics – can be determined at will and thus used for many purposes.

Natural fibers are categorized into plant fibers (such as cotton) and animal fibers (such as silk). While plant fibers are made of cellulose, animal fibers are composed mainly of proteins.

Synthetic fibers are divided into fibers made of natural polymers (base material: cellulose), such as viscose, and fibers made of synthetic polymers (base material: petroleum oil), such as polyamide and spandex fiber.

COTTON

Cotton yarn is spun from the seed hair of various types of bushy members of the mallow family. It is grown in more than 60 countries. The most important cultivation countries are China, the USA, the CIS states and Pakistan. The oldest evidence of the cotton trade has been found in India (3000 BC). The native inhabitants of America were also familiar with cotton long before the Arabs introduced it to Europe. The cotton industry experienced its major upswing with the invention of the spinning machine in the18th Century, first in England and later in France and Germany.

Cotton is extremely comfortable on the skin as it is breathable and can absorb up to 20% of its weight in moisture without feeling wet. It is light and washproof, tear-resistant and does not felt.

SILK

These shiny fibers are created by silkworm pupae. Silk production goes back to the 3rd Century B.C. in China. Silk was introduced to the West for the most part over the famous Silk Road. Silkworms are bred primarily in China, India, Japan and Russia. This luxurious fabric hardy wrinkles, is pleasantly cool in summer, warm in water, has good moisture absorption qualities and is lightweight and smooth as a result of its low density. Silk is the most elastic of all natural fibers. It is very sensitive to sweat, sunlight and alkaline solutions, however.

JERSEY

The name of this material comes from the island of Jersey in the English Channel where jersey was first made. Jersey is a knitted fabric which comes in a wide variety of types. It has a soft, full feel and good shearing resistance.

SINGLE-JERSEY

The two sides of this smooth, knitted fabric look very different from each other. Right loops are visible on one side of the material and left loops on the other. The material is not very elastic and is often used as a print background for allover prints or printed motifs. During wet processing, knitted good always shrink in the lengthwise direction.

VISCOSE

This continuous filament yarn made of natural polymers (cellulose) was one of the first synthetic fibers. Viscose is used alone or in a blend with other synthetic or natural fibers. This fiber is pleasant to the touch, especially soft and adjusts to the contours of the body. It can easily be dyed and printed, has good color retention qualities, is highly resistant to light, absorbs moisture well and yet has a low wet strength.

LYOCELL

A cellulose synthetic fiber that offers all the advantages of a natural material and is 100% biologically degradable. Lyocell is very easy to care for, dyes well and has a cool, silky character with especially good moisture and heat transport qualities. It wet strength is 20% above the wet strength of viscose. Lyocell is known under the name Tencel®, for example.

ACETATE

A synthetic fiber made of a cellulose bond with acetic acid. Commonly referred to as a cellulose derivates, acetate fabrics have a full feel, an elegant drape, high elasticity and shape retention and a glowing matte shine.

POLYAMIDE A synthetic fiber group of varying chemical compositions, classifications and properties. Polyamide fibers were developed in America and first introduced in 1935. Polyamide was also discovered in Germany at almost exactly the same time and manufactured under the name perlon. This material allowed clothing to fulfill functional demands that had previously been impossible. Polyamide fibers are very stable and robust, highly tear-resistant, wear-resistant and flexible. They are lightweight and delicate, extremely elastic, guarantee good shape retention, do not wrinkle easily, are easy to wash and dry quickly. They are sensitive to dry heat, however. Polyamide is known under brand names such as Tactel® or Meryl®.

SPANDEX The spandex fiber filament is extremely flexible. It can be stretched to 6-8 times its original length and returns to its original form after the tension is released, thus guaranteeing an optimal fit. It is very resistant to tearing and can be easily washed and dyed.
Spandex fiber is always mixed with other yarns in order to give textiles high stretchability and elasticity. Spandex fiber is know under the trade names Lycra® from Du Pont, first introduced in 1959 in America, and Dorlastan®, introduced to market in 1964 by Bayer.

LYCRA® Registered trademark for the spandex fiber from Du Pont. Lycra® is resilient and resistant to aging, saltwater and sunlight.

MERYL® A synthetic fiber made of polyamide. It is extremely fine, very robust, elastic and dries quickly.

MACTEL® A synthetic fiber based on polyamides. Tactel® ensures a perfect fit; is lightweight, soft and silky; easy to care for; breathable and naturally transports moisture away from the skin to keep it cool and dry.

TENCEL® A type of lyocell fiber introduced to market in 1992. The fiber is very easy to care for and has a high level of fiber and wet strength. It is sometimes used alone and sometimes mixed with cotton, linen, silk, viscose or wool.

MICRO-FIBER

Micro-fibers are extremely fine, lightweight fibers made primarily of polyamide, polyester or viscose.

In the textile industry, fibers are defined according to type of material as well as degree of fineness. The measuring unit DEZITEX (dtex) is used for the filament yarns (continuous filament yarn = synthetic fibers). This index indicates how many grams a piece of thread 10,000 meters long weighs. A dtex of I means that 10,000 meters weigh one gram.

FINE RIB AND DOUBLE RIB

Fine rip is a classic knitted fabric produced on fine-rib machines. It has right loops on both sides. The transition from left to right loop is visible only when the fabric is stretched.

A knitted fabric, double rib is produced on circular knitting machines and has alternating double right and double left loops.

BOXER SHORTS

Popular in America since the early 1920s, boxer shorts did
not become well known in Europe until after the Second World War.
Patterned or with colorful prints such as kisses, hearts or cartoon
characters, they became a bestseller in the 1980s.
Boxer shorts are also worn as nightwear or beachwear.

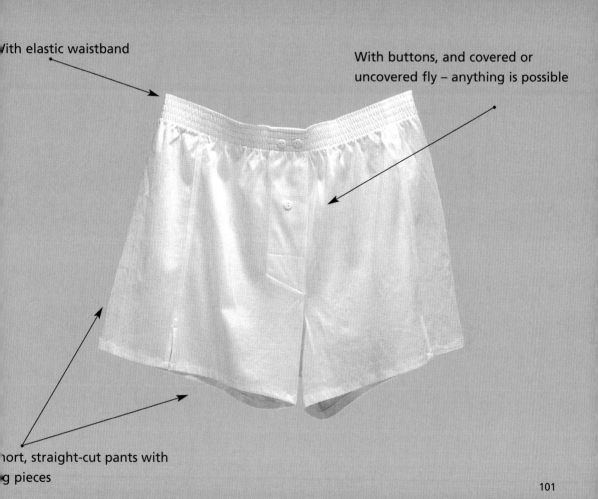

With elastic waistband

With buttons, and covered or
uncovered fly – anything is possible

Short, straight-cut pants with
leg pieces

Rösch

eys, Florida

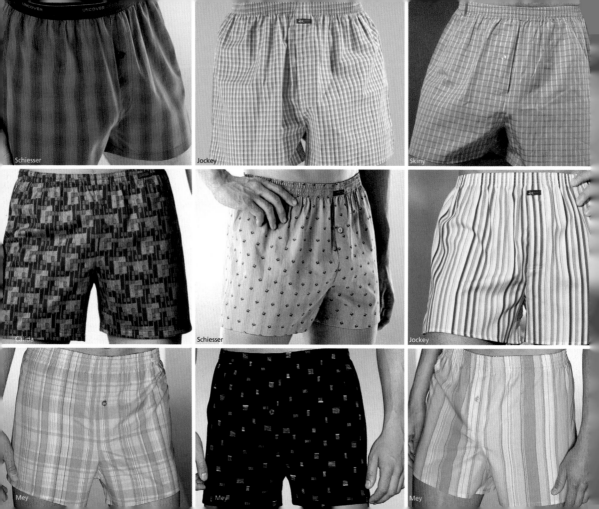

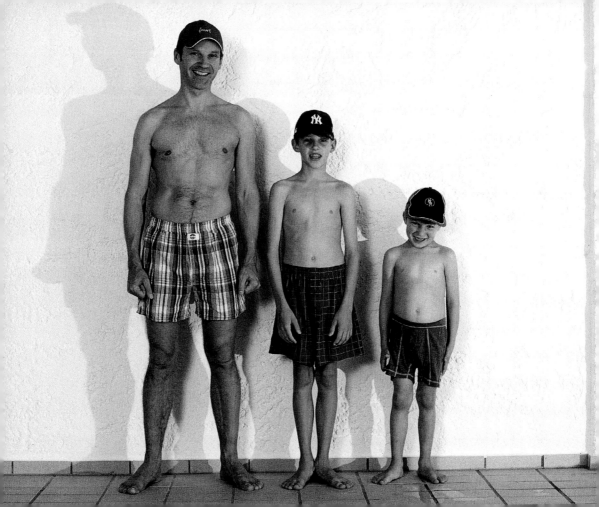

FLIRTING WITH THE IMAGINATION

Alfons Kreuzer has devoted his career to designing men's underwear since the 1980s. He is the creator of the Olaf Benz brand, which is now internationally successful. In 1996, the designer also acquired the trademark rights to Manstore.

You are the creator of the Olaf Benz brand and its designer. Why did you choose underwear in particular?
I have always liked attractive underwear. And because I always had better, more attractive underwear than my buddies, they sometimes gave me money and asked me to buy them some, too. They didn't even know where such styles could be bought. You might say I started as an "underwear dealer." At some point I used my experience as a graphic designer to develop an entire collection under the name Olaf Benz. With my background in advertising, I also know how to launch a brand. The result is that Olaf Benz is now one of the top ten designer underwear brands.

What is the process of designing underwear like for you?
As a designer, I flirt with the imagination. I want to re-invent the concept of underwear with each new collection. I am enthusiastic and passionate about my work. I have to feel the spirit of the times, be ahead of trends, implicitly know what is "in." And I am sure that this creative spirit is also evident in the models. Olaf Benz has energy, it has character and Olaf Benz is addictive. I simply have to want more than just a designer name printed on the elastic waist band.

Calvin Klein's collections are very successful.
Of course. He has done a lot for men's underwear. I admire his campaigns and am impressed by his business finesse. In terms of design, however, I don't see anything special but the CK lettering. I see myself first and foremost as a creative personality. But innovative ideas alone are not enough. Everything I make has to fit perfectly, must convey a unique wearing sensation and has to be different from the rest. Underwear from Olaf Benz is clearly aimed at men who are body-conscious. They know that only those who dress themselves well can also undress themselves well. I want unusual but not foolish-looking underwear for men. That is the challenge design must meet, otherwise one can quickly be overstyled.

What were your greatest design highlights?
The patented invention with the scent pad is certainly one of them. It is a small pillow which can be filled with the wearer's favorite perfume. The trick is the pure, clear exuding of the scent, without it being mixed with the smell of sweat as can happen with deodorant sprays.

In 2000, I developed the Olaf Benz Gold collection, which is optimized for various types of sports. NOC was very

pleased by that. This is why the German Olympic team for Sydney was outfitted with Olaf Benz Gold. As a designer, I am especially interested in how underwear looks. After all, sports underwear doesn't have to look like it was ordered by the healthcare authorities.

I AM NOT A MISSIONARY

Does underwear now contribute to the fashionableness of the overall outfit? How important is underwear for men today?

The average man naturally has more underwear in his closet today than he did ten years ago. Statistically I believe it was 2.3 pairs back then. Certainly men also now have a few pairs of good underwear for special occasions as well. These are often a matter of necessity rather than please, however, to avoid embarrassment on important occasions. The core market for designer underwear, on the other hand, is small but exciting. Those who value how they look in their underwear, however, don't scrimp on money. Young people are our future here, by the way. They enjoy looking sexy. The boys work out at the gym, have tattoos and dance on the table. Think of the Love Parade, for example. Young people in particular enjoy attractive underwear and they will retain this preference. Men in their mid-thirties and older, possibly married, don't really exercise that much. They think they don't need to work on their bodies anymore. This annoys a lot of women. But I am not a missionary. I don't want to explain how life works to anyone.

The Olaf Benz image was relaunched in 1999. Fire red became the brand color.

Well, I started off as a graphic artist and photographer. Its only natural that I take care of marketing, too. The change to red gave us a distinguishing feature. It immediately attracts the eye of everyone who enters the shops. We have also developed a very intensive photographic style for Olaf Benz with highly erotic pictures that stimulate the imagination.

What is your impetus, your motivation as a designer?

That is always the response from outside – when a model at a fashion show comes to me and says, "Hey, this is the best underwear I've ever worn." Or when I see Olaf Benz with a premium positioning at KaDeWe in Berlin or at Galeries Lafayette in Paris or at Bloomingdales in New York. It is like I have been electrified, and I immediately begin to think up new models.

And what do you wear underneath?

Olaf Benz of course. And I really do wear everything that I design – hot pants, briefs, strings, everything. I always have to find out for myself how it fits, if it works, whether or not it is perfect. You might say I am my own test wearer. And I still love the good feeling that wearing carefully chosen underwear brings with it. That is what I share with many Olaf Benz customers – I am addicted to that feeling.

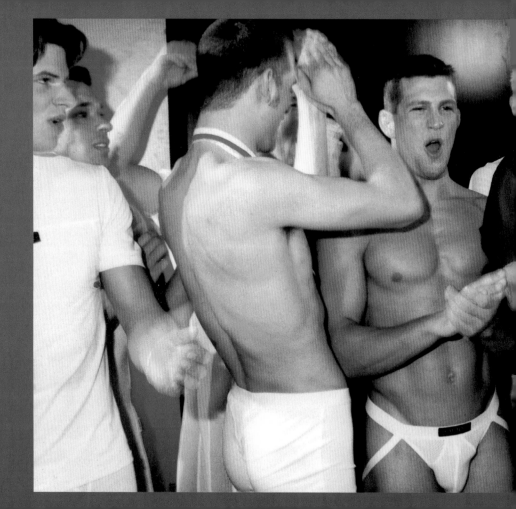

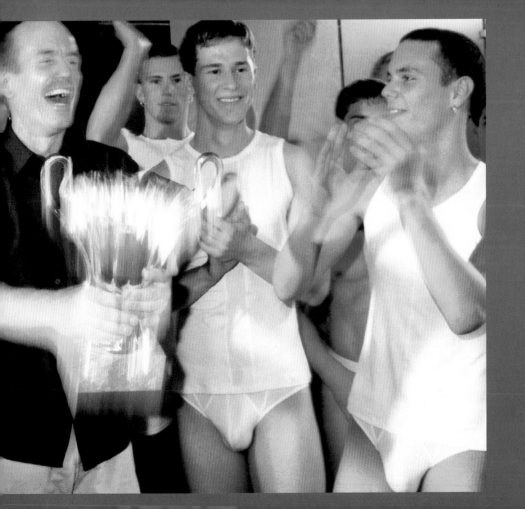

THE STRING

... the most minimal of underwear.

The first men's string was designed by French top designer Paco Rabanne.
A distinction is drawn between the regular string and the g-string.

The string has very little fabric. The front and back are connected to each other with strings

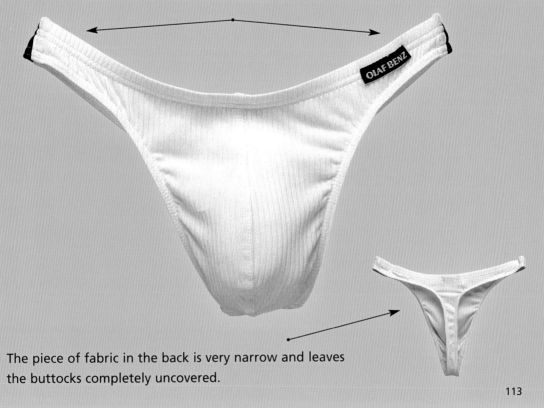

OLAF BENZ

The piece of fabric in the back is very narrow and leaves the buttocks completely uncovered.

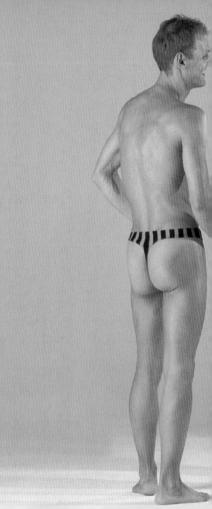

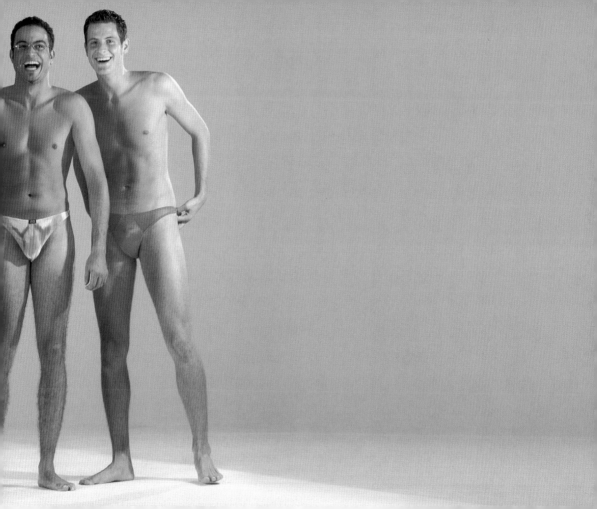

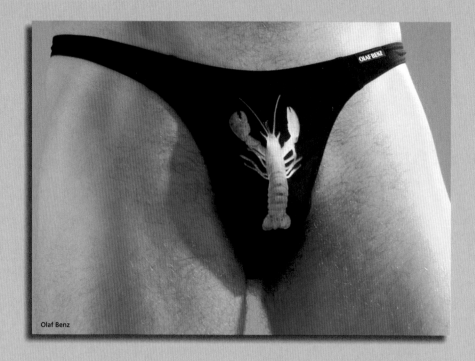

Olaf Benz

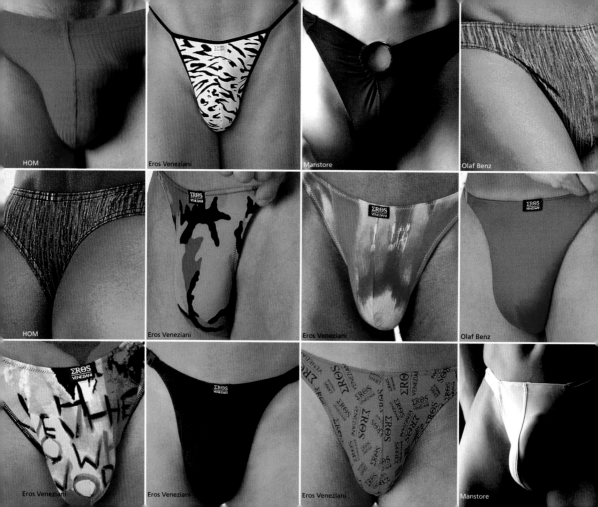

HOM

Eros Veneziani

Manstore

Olaf Benz

HOM

Eros Veneziani

Eros Veneziani

Olaf Benz

Eros Veneziani

Eros Veneziani

Eros Veneziani

Manstore

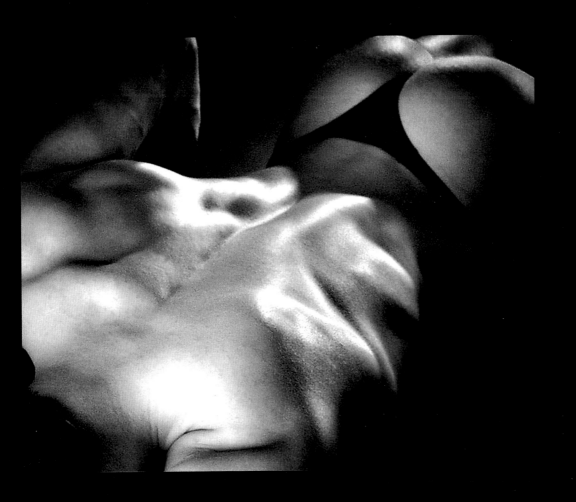

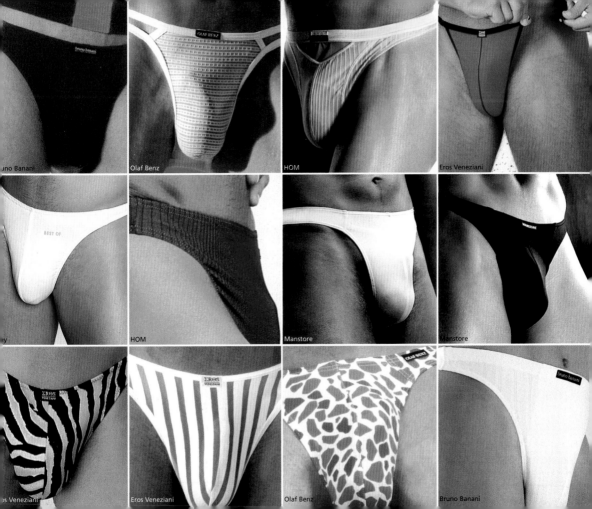

uno Banani

Olaf Benz

HOM

Eros Veneziani

ey

HOM

Manstore

Manstore

os Veneziani

Eros Veneziani

Olaf Benz

Bruno Banani

THE JOCK STRAP

The jock strap is a highly erotic form of brief.
In fact, however, many men wear it for playing sports.

When it fits perfectly, a jock strap provides good support in the front

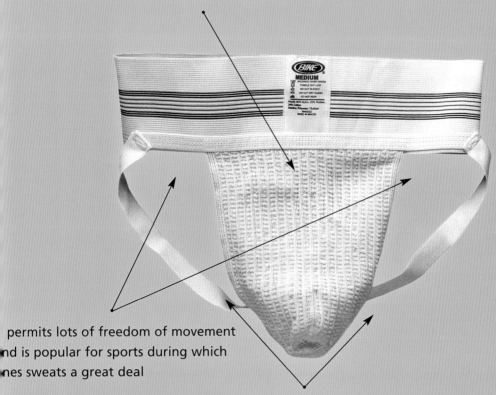

permits lots of freedom of movement
nd is popular for sports during which
nes sweats a great deal

Instead of fabric, the back is made of two straps which run
along or under the buttocks

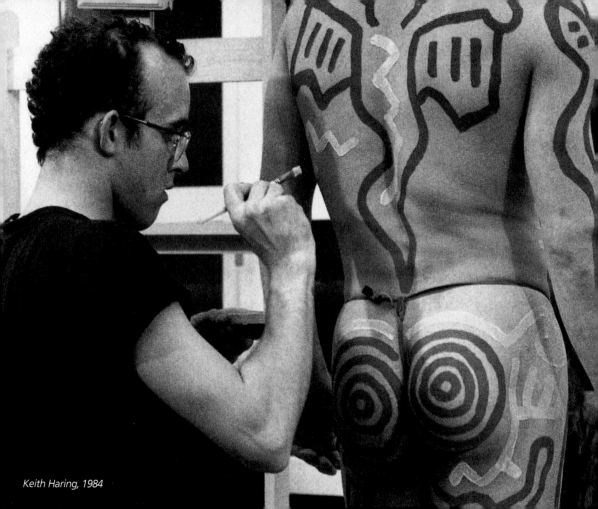

Keith Haring, 1984

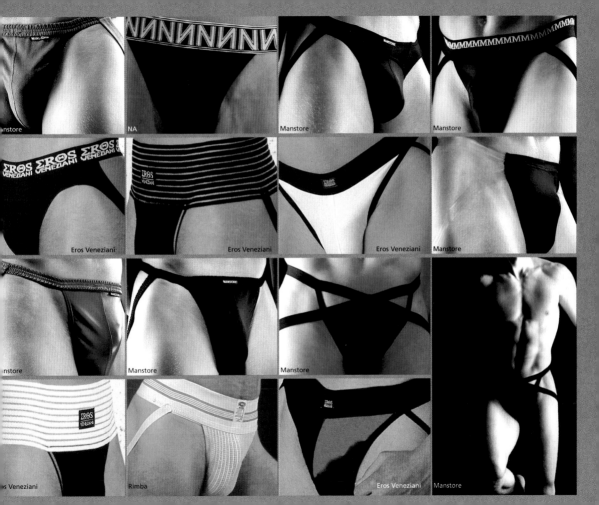

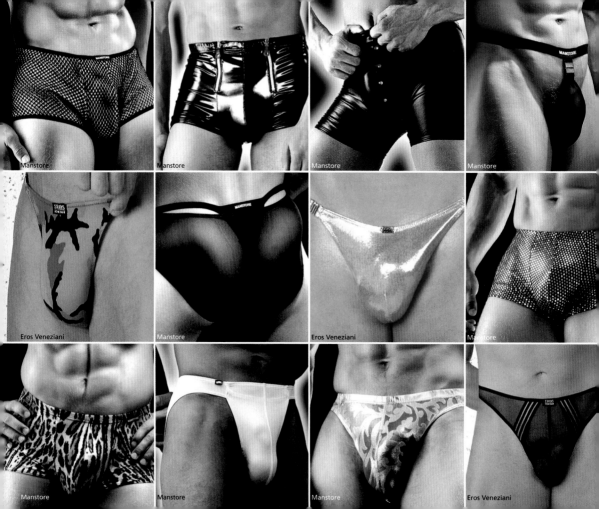

Manstore

Manstore

Manstore

Manstore

Eros Veneziani

Manstore

Eros Veneziani

Manstore

Manstore

Manstore

Manstore

Eros Veneziani

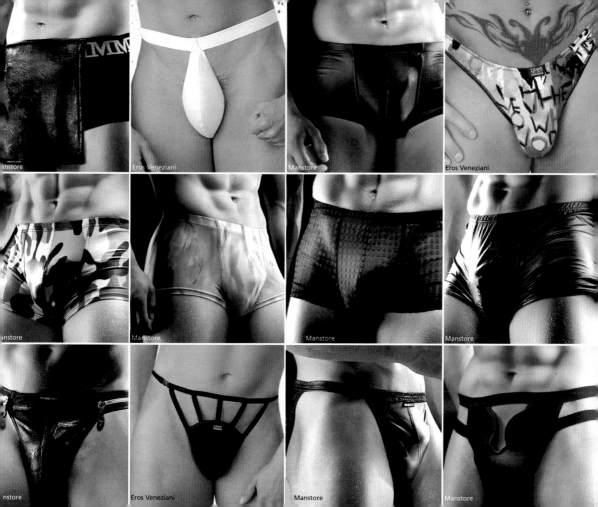

nstore

Eros Veneziani

Manstore

Eros Veneziani

nstore

Manstore

Manstore

Manstore

nstore

Eros Veneziani

Manstore

Manstore

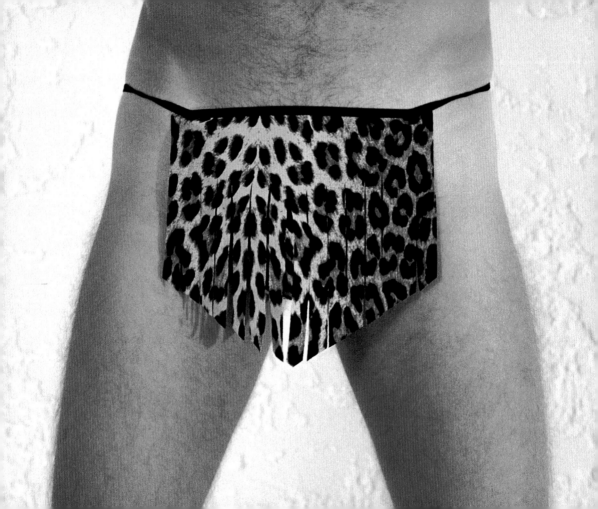

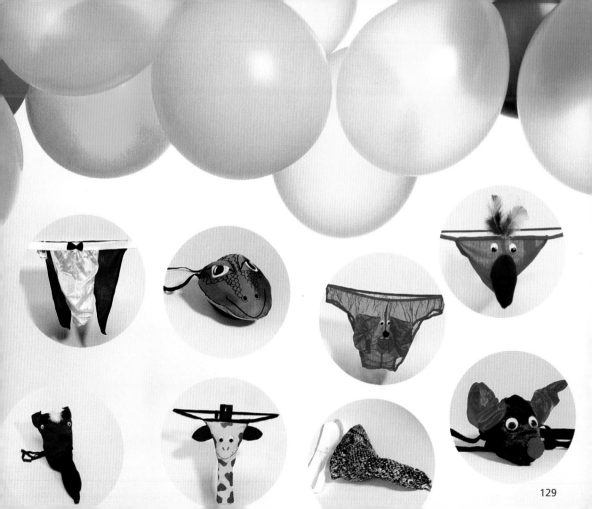

129

WASHING
THERE'S NO WAY AROUND IT

Could anyone conceive of life without a washing machine in this day and age? Certainly not! James T. King invented the cylinder washing machine in 1851. His basic concept is still evident in today's models. Carl Miele and Reinhard Zinkann sold their first wooden washing machine in 1901. It had a cross handle on the inside which were used to tumble the wash. In 1914, the washing machine became independent with the help of an electric motor. The world's first fully automatic washing machine was introduced to market in 1946 in the USA. It was not until the late 1960s, however, that the washing machine became a standard appliance in every household. Quick and easy washing of clothing without much thought being given to the activity has now become the norm. While the cylinder washing machine is dominant in Europe, the top loader (tub washing machine) is most popular in the USA and Japan.

When Klementine appeared daily on German TV screens more than 30 years ago promising "Wäscht nicht nur sauber, sondern rein" ("It doesn't just wash things clean, it washes them pure"), she quickly won over the hearts of housewives everywhere. Klementine became the cult figure of the nation and a 10kg package of washing powder soon became a standard household item.

Ashes and soap were long used as the medium for removing dirt from clothing. Clothing was soaked in water to which grated soap had been added and was then pounded, rubbed, beaten and brushed. Then the laundry, specifically the white laundry, was bleached. Small items were placed in boiling water on the stove.

In Germany, "Henkel's Bleichsoda" was introduced to market in 1878 and was a forerunner

to modern washing powder. It consisted of sodium carbonate and sodium silicate. In 1907, Fritz Henkel developed the world's first automatic washing powder, Persil. It could wash and bleach fabrics and made complicated bleaching in the backyard or village field unnecessary. The brand name Persil was derived from the first letters of the most important ingredients: perborate (which provided the bleaching oxygen) and silicate (which prevented interference of the bleaching effect).

Much development was needed, however, before the quality of today's highly modern washing powders was achieved. The simplification of the washing procedure and the improvement of its results were the focus of attention until well into the 1950s. In the 1960s, the spotlight gradually shifted to ecological and environmental issues. The Washing and Cleansing Agents Act was passed in Germany in 1975. This law, which has meanwhile been revised several times, stipulates the disclosure of formulas, sets limit values for chemicals and obligates manufacturers to indicate the yield and correct amount to use on the packaging of the detergent.

Finding one's way around today's jungle of detergents is no easy job. Power, tabs, gel, pearls, liquid detergents – they all promise gentle, one-hundred percent cleaning. But which detergent should be used for what type of laundry and how do the different types work?

A basic distinction is drawn between heavy-duty, color and mild detergent.

Heavy-duty detergents are suitable for any temperature up to 95° C, they have a high level of washing power and contain bleaching and brightening agents. But be careful! Liquid heavy-duty detergents do not contain the bleaching agents found in powders. White laundry thus turns gray over time. Some of them also contain more tenside, which increases the stress placed on the environment.

Heavy-duty detergents are not suitable for colored fabrics as they change colors and cause them to become lighter. Color detergents are therefore the medium of choice for colored fabrics. They are effective up to 60° C, contain no brightening or bleaching agents and protect colors.

Mild detergents are used to wash wool, silk and certain synthetic fibers at a wash temperature of up to 30° C. They also contain no brightening or bleaching agents.

* Newly purchased clothing should always be washed before wearing so that the chemicals used during manufacturing do not come in contact with the skin.

* Always keep white laundry and colored laundry separate as the white laundry will other wise turn gray. If the fabric is already gray, add bleach booster to the wash cycle.

* Modern detergents and washing machine technology often render prewashing unnecessary. The main wash cycle is usually sufficient.

* Only the clothing of sick persons and infants should be washed in boiling water of 95° C. Washing at 65° C works just as well as washing in boiling water.

* If the laundry is very dirty, it should be soaked before being washed. Colored laundry should be soaked for a short period of time, at most one hour, and never in hot water.

* Close any buttons or zippers.
 Turn laundry with a gloss finish inside out as this will protect it.
 Place sensitive pieces in a wash bag. A pillowcase can be used instead.

* It is best not to following the old housewife's custom of lining closets with paper, as unwanted pests like to hide under it.

WASHING

 Washing

The numbers in the wash tub indicate the maximum wash temperature, which should not be exceeded. A bar underneath the wash tub indicates that a more mild (mechanical) treatment is necessary, i.e. gentle cycle.

 Gentle cycle

If the wash tub contains points instead of numbers, it is referring the American symbol system. The points (which vary in number from one to six points) indicate the maximum wash temperature. One point indicates 30° C, six points 95° C.

The American and European symbol systems for ironing, dry cleaning and bleaching are mostly the same.

By the way, the European care symbols have been established by the International Association for Textile Care Labelling "GINETEX" and are mandatory for all EU countries.

 Hand wash

A hand in the wash tub indicates hand wash.

A wash tub that has been crossed out indicates the item should not be machine washed.

IRONING

The points in the iron indicate the temperature at which the item can be ironed. Three points indicate the highest level (1 point = 110°, 2 points =150°, 3 points = 220°)

If the item should not be ironed, the iron is crossed out

DRYING

The points indicate the drying level. One point means the item should be dried at reduced thermal stress, two points indicate normal thermal stress.

If the symbol contains a bar, it is part of the American symbol system and indicates drying as easycare wash, two bars indicate drying as delicate wash.

If the item should not be placed in the dryer, the dryer is crossed out.

DRY CLEANING

The letters are for the dry cleaner and indicate which solvents can be used.

A crossed-out circle indicates that dry cleaning is not recommended.

BLEACHING

Chlorine bleaching is possible

If the symbol has been crossed out, the item should not be bleached.

There is no symbol for spinning. Delicate wash should only be spun at low speeds. Very delicate wash, such as silk, should not be spun at all.

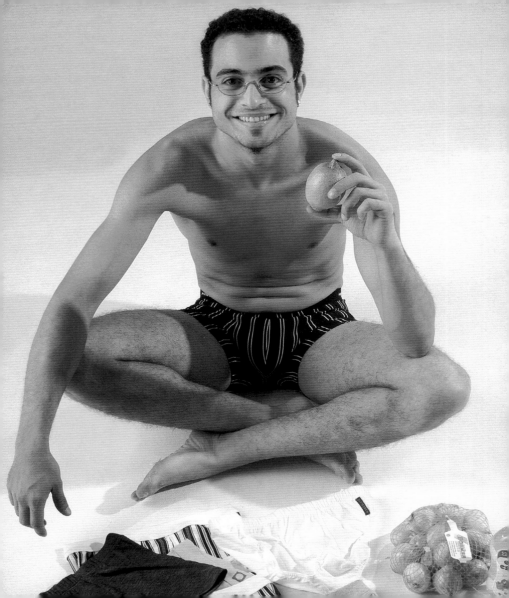

WHAT CAN BE DONE ABOUT STUBBORN STAINS IN LAUNDRY?

Breakfast in bed, an intimate rendezvous in a green meadow, a cozy evening with red wine in front of the fireplace. Unfortunately, underwear is not immune to stubborn stains either. Whether sperm, lipstick, grass, red wine or blood – removing the evidence is sometimes a real art form. Special stain removers are available in drug stores, but conventional home remedies are just as effective. Immediate treatment of the stain is important, as it is easiest to remove when fresh. Never rub the fabric, as this will damage the material and will only leave your favorite underwear looking worse than before. To avoid irreparable damage, please follow the manufacturer's care instructions.

* Sperm stains can only be treated with cold water, as the protein coagulates in hot water and binds with the fabric. The same applies to blood stains. Soak the stains and wash them in cold water with detergent. The item can also be soaked in salt water and then treated with bile soap.

* A thick layer of salt should be scattered on red wine stains. Red wine stains can also be removed from white laundry by adding bleach to the washing machine.

* Before washing, rub beer stains with warm, diluted vinegar; old stains should first be soaked in a little glycerin.

* Iron out candle and wax stain with blotting paper. A hot knife can be used instead of an iron.

* Coffee stains can be removed with lukewarm, mild soapy water.

* Stains containing oil, such as make-up or lipstick, should be washed with dishwashing liquid or bile soap and warm water.

* Dampen grass stains with lemon juice and then rinse them with warm water. Bile soap also works.

* Urine stains should first be washed in cold or at most in lukewarm or soapy water and then rinsed in hot water. Any remaining outlines of the stain should then be treated with white spirit or lemon juice. Urine stains will disappear from boilingproof laundry during the usual washing procedure.

* Areas that have turned yellow or been scorched by ironing will become white again when immediately washed with vinegar or when rubbed with onion juice. Rinse immediately with cold water.

* Mold stains are difficult to remove. Soak the laundry in sour milk and then wash as usual.

* Rust stains are very stubborn and can hardly ever be removed completely. Repeated sprinkling with lemon juice will lighten the stain.

Photo credits

The publishing company thanks the manufacturers, photographers, archivists and mail-order firms for the granting of reproduction rights. The publishing company attempted to find all owners of image rights until completion of production.

© Peter Adler: 5; © Arthothek, Weilheim: 7; Werner Stapelfeldt: 8-9, 34-35, 48-49, 68-69, 76-77, 94-95, 100-101, 107, 112-113, 122-123, 128-129, 134; © Schiesser, Radolfzell: 10,17,18, 25, 57; © Neckermann, Frankfurt a. M.: 11; Ruprecht Stempell: 12, 32-33, 36-37, 56, 70, 72r., 73, 74-75, 78-79, 102-103, 114-115, 116, 131, 138, 144; © Alfons Kreuzer: 13, 110-111; © Jockey, Götzis, Österreich/USA: 16, 19, 20-21, 22, 66; © Palmers, Wiener Neudorf, Österreich: 23, 63; © Günter Beer: 117; © Calida, Sursee, Schweitz: 24, 59; © HOM, Grasberg: 25, 41, 61u.; © Stephan Adam: 26; © Mahl/Sipa Press, Paris: 27; © David Bradford: 29; © Mey, Bitz: 52, 60u., 61o., 72; © foto: Bernd Kammerer, model: Patrick, m4 models: 53; © Gebrüder Wolff, Hard, Österreich: 55; © M & C Vertrieb München: 58; © G+M Textil GmbH, Bisingen: 60o.; © Huber, Götzis, Österreich: 62o.; © Skiny, Götzis, Österreich: 62m.; © Rösch, Tübingen: 62u., 105; © Jordi Miralles: 103; © Punto Blanco, Spanien/Promise Deutschland, Fürth: 64; © ESGE Albstadt: 65, 88; © Premium Wittgensdorf: 67; © foto: Jörg Schieferecke, model Micaiah, Modelwerk Hamburg: 83; © Rainer W. Schlegelmilch: 120; Armin Faber/Thomas Pothmann: 129o., 141; Michael Baron von Capitaine: 130, 133; © Benjamin Katz: 124; © Achim Bednorz: 82; Seite 38-39 von rechts nach links: Quelle, foto: Hans Kollmar, model: Richard; Mey, Bitz; HOM, Grasberg; G+M Textil GmbH, Bisingen; drunter & drüber, Frankfurt a. M.; Premium Bodywear, Chemnitz; foto: Jens Ihnken, model: Tim, m4 models; HOM Grasberg; foto: Jens Ihnken, model: Tim, m4 models; Mey, Bitz; Seite 42: Premium Bodywear, Chemnitz; Seite 43 von rechts nach links: Jockey, Götzis Österreich; Mey, Bitz; Schiesser, Radolfzell; drunter & drüber, Frankfurt a. M.; Gebrüder Wolff, Hard Österreich; M & C Vertrieb München; HOM, Grasberg; Premium Bodywear, Chemnitz; Premium Bodywear, Chemnitz; Seite 44-45: HOM, Grasberg; HOM, Grasberg; HOM, Grasberg; Promise Deutschland, Fürth; HOM, Grasberg; M & C Vertrieb München; Gebrüder Wolff; drunter & drüber, Frankfurt a. M.; Promise Deutschland, Fürth; Mey, Bitz; Calida, Sursee, Schweitz; Calida, Sursee, Schweitz; Schiesser, Radolfzell; HOM, Grasberg; foto: Jörg Schieferecke, model: Micaiah, Modelwerk Hamburg; HOM, Grasberg; ESGE Albstadt; HOM, Grasberg; Palmers, Wiener Neudorf, Österreich; Promise Deutschland, Fürth; Premium Bodywear, Chemnitz; Calida, Sursee, Schweitz; HOM, Grasberg; Seite 46 von rechts nach links: Premium Bodywear, Chemnitz; drunter & drüber, Frankfurt a. M.; drunter & drüber, Frankfurt a. M.; drunter & drüber, Frankfurt a. M.; Premium Bodywear, Chemnitz; drunter & drüber, Frankfurt a. M.; drunter & drüber, Frankfurt a. M.; HOM, Grasberg; Rösch, Tübingen; Seite 50 von links nach rechts: drunter & drüber, Frankfurt a. M.; M & C Vertrieb München; M & C Vertrieb München; drunter & drüber, Frankfurt a. M.; Seite 51 von links nach rechts: Calida, Sursee, Schweitz; M & C Vertrieb München; M & C Vertrieb München; M & C Vertrieb München; drunter & drüber, Frankfurt a. M.; Premium Bodywear, Chemnitz; M & C Vertrieb München; M & C Vertrieb München; drunter & drüber, Frankfurt a. M.; Seite 80-81 von links nach rechts: drunter & drüber, Frankfurt a. M.; G+M Textil GmbH, Bisingen; Rösch, Tübingen; HOM, Grasberg; Huber, Götzis; Mey, Bitz; Calida, Sursee, Schweitz; foto: Jens Ihnken, model: Tim, m4 models; HOM Grasberg; Seite 84-85 von links nach rechts: Mey, Bitz; Promise Deutschland, Fürth; foto: Jörg Schieferecke, model: Javier, Unity Model; ESGE Albstadt; Premium Bodywear, Chemnitz; Mey, Bitz; ESGE Albstadt; Gebrüder Wolff Hard Österreich; ESGE Albstadt; Premium Bodywear, Chemnitz; foto: bernd Kammerer, model: Patrick, m4 models; HOM Grasberg; Gebrüder Wolff Hard Österreich; drunter & drüber, Frankfurt a. M.; HOM Grasberg; HOM Grasberg; Premium Bodywear, Chemnitz; M & C Vertrieb München; Skiny Götzis Österreich; HOM Grasberg; drunter & drüber, Frankfurt a. M.; Gebrüder Wolff Hard Österreich; Schiesser Radolfzell; Seite 86-87 von links nach rechts: M & C Vertrieb München; Premium Bodywear, Chemnitz;

mium Bodywear, Chemnitz; drunter & drüber, Frankfurt a. M.; Jockey, Götzis Österreich; drunter & drüber, Frankfurt a. M.; drunter & ber, Frankfurt a. M.; Huber, Götzis Österreich; M & C Vertrieb München; Premium Bodywear, Chemnitz; M & C Vertrieb München; mium Bodywear, Chemnitz; Neckermann, Frankfurt a. M.; foto: Jörg Schieferecke, model: Javier, Unity Model; Quelle Fürth; foto: Jörg ieferecke, model: Javier, Unity Model; HOM Grasberg; M & C Vertrieb München; Premium Bodywear, Chemnitz; Promise Deutschland, th; Quelle Fürth; drunter & drüber, Frankfurt a. M.; Premium Bodywear, Chemnitz; Seite 90-91 von links nach rechts: HOM Grasberg; nter & drüber, Frankfurt a. M.; Mey, Bitz; Mey, Bitz; Premium Bodywear, Chemnitz; drunter & drüber, Frankfurt a. M.; drunter & ber, Frankfurt a. M.; ESGE Albstadt; HOM Grasberg; HOM Grasberg; HOM Grasberg; foto: Bernd Kammerer, model: Patrick, m4 dels; Mey, Bitz; HOM Grasberg; Rösch, Tübingen; Promise Deutschland, Fürth; 3. Reihe: Mey, Bitz; Mey, Bitz; HOM Grasberg; Promise utschland, Fürth; Promise Deutschland, Fürth; Jockey, Götzis Österreich; Premium Bodywear, Chemnitz; HOM Grasberg; Seite 92 von ks nach rechts: HOM Grasberg; drunter & drüber, Frankfurt a. M.; drunter & drüber, Frankfurt a. M.; Premium Bodywear, Chemnitz; M Vertrieb München; drunter & drüber, Frankfurt a. M.; HOM Grasberg; drunter & drüber, Frankfurt a. M.; M & C Vertrieb München; nter & drüber, Frankfurt a. M.; M & C Vertrieb München; M & C Vertrieb München; Seite 93: G+M Textil GmbH, Bisingen; Seite 106 links nach rechts: Schiesser, Radolfzell; Jockey, Götzis Österreich; Skiny, Götzis Österreich; Calida, Sursee, Schweitz; Schiesser, dolfzell; Jockey, Götzis Österreich; Mey, Bitz; Mey, Bitz; Mey, Bitz; Seite 118 von links nach rechts: HOM Grasberg; M & C Vertrieb nchen; Premium Bodywear, Chemnitz; Premium Bodywear, Chemnitz; HOM Grasberg; M & C Vertrieb München; M & C Vertrieb nchen; Premium Bodywear, Chemnitz; M & C Vertrieb München; M & C Vertrieb München; M & C Vertrieb München; Premium dywear, Chemnitz; Seite 119: Premium Bodywear, Chemnitz; Seite 121 von links nach rechts: foto: Jörg Schieferecke, model: Micaiah, delwerk Hamburg; Premium Bodywear, Chemnitz; HOM Grasberg; Mey, Bitz; HOM Grasberg; Premium Bodywear, Chemnitz; Premium dywear, Chemnitz; M & C Vertrieb München; M & C Vertrieb München; Premium Bodywear, Chemnitz; foto: Jens Ihnken, model: Lee, 1. Fotomodell-Service; Seite 126-127 von links nach rechts: 1-5: Premium Bodywear, Chemnitz; M & C Vertrieb München; Premium dywear, Chemnitz; M & C Vertrieb München; M & C Vertrieb München; Premium Bodywear, Chemnitz; M & C Vertrieb München; 12-19: mium Bodywear, Chemnitz; M & C Vertrieb München; Premium Bodywear, Chemnitz; M & C Vertrieb München; Premium Bodywear, emnitz; Premium Bodywear, Chemnitz;

would like to thank all the companies and institutions for their kind support!
ecial thanks to Marco, Tarek, Eddie, Marlon, Tim and TUS Rhode.

w.rimba.nl; www.brunobanani.com; www.quelle.de; www.neckermann.de; www.calida.com; www.esge.de; www.hanro.ch; ww.jockey.com; www.mey.de; www.olafbenz.de; www.gerhard-roesch.de; www.schiesser.de; www.skiny.com; www.huber-tricot.com; ww.erosveneziani.it; www.wolff.at; www.puntoblanco.com; www.bader.de; www.underwear-shop24.com; w.drunter-und-drueber.de; www.bodyart.com; www.hom-fashion.com; www.palmers-shop.com